DIGITAL PHOTOGRAPHY

NICK VANDOME

In easy steps is an imprint of Computer Step
Southfield Road · Southam
Warwickshire CV47 0FB · United Kingdom
www.ineasysteps.com

Fifth Edition

Notice of Liability
Every effort has been made to ensure that this book contains accurate and
current information. However, Computer Step and the author shall not be
liable for any loss or damage suffered by readers as a result of any information
contained herein.

Trademarks
All trademarks are acknowledged as belonging to their respective companies.

Printed and bound in the United Kingdom

ISBN 1-84078-298-6

Table of Contents

Obtaining prints

Sharing images

Index

Filmless photography

This chapter introduces the basics of digital photography and shows the uses to which it can be put. It covers some of the advantages and drawbacks of digital photography and has an overview of how digital cameras operate and some of the issues relating to digital images, such as pixels and resolution.

Covers

Defining digital photography

Digital photography now has a firm foothold in the mass-market category and in some countries is starting to overtake film-based photography. Computer and software manufacturers are working hard to ensure that it is as easy as possible for users to capture and use digital images.

With recent advances in electronic and computing technology it seems that all of the familiar gadgets around us are being converted into digital versions: televisions, telephones, radios, camcorders and, of course, cameras. The main reasons for this are quality and speed of delivery of information.

Photography has been a willing participant in the digital revolution and it is now becoming strongly established in both the commercial and consumer markets. At first sight, though, digital photography can appear confusing to the uninitiated: in addition to cameras there are computers, image editing software, printers, scanners and a host of other add-ons and peripherals. But the good news is that once some of the technical jargon has been stripped away digital photography is relatively straightforward: you take a picture in the traditional way but with a digital camera; you transfer the image onto a computer; you improve, enhance and edit the image; the final version is then printed, shared on a Web page, or displayed on a monitor.

Digital photography is a marriage between photographic techniques and computer technology. If you are interested in both then you will take to it like a duck to water. If your main interest is in one or other of the processes then you will have some enjoyable discoveries as you experience the other side of the equation.

The starting point of any digital photography career is the camera. More and more of these are now appearing in both photographic and computer retail outlets and the choice and quality are increasing continually. Some digital cameras look almost identical to their film counterparts, so there is no need to readjust your perceptions on this front.

Using digital photography

There are a variety of ways of capturing digital images and using them but the basic process with a camera is:

- Begin the digital process by capturing an image with a digital camera

- Download and edit images on a computer

- Print out a hard copy of images

- Share images online

- Obtain prints directly from camera memory cards

The first digital steps

As far as capturing an image is concerned, digital photography differs very little from film photography. In both cases an image is seen through a viewing device and then light from the displayed image is recorded within the camera. It is in differing methods of recording the amount of light that the first big difference between film and digital photography lies. In the former, the light creates an image on photographic film. This is then developed into a photograph using a combination of chemicals. Digital photography is a lot less messy: the light that comes through the lens is recorded on a tiny computer chip (known as an image sensor). These contain hundreds of thousands or millions of devices called photosites, each of which stores electronic data about the amount of light that falls on it. Once the image has been captured by the image sensor this data is then sent to an Analog to Digital Converter (ADC), which converts the image information into a format that can be interpreted by a computer.

Once the photograph is taken, all similarity between traditional and digital photography ceases. A film image can be developed into a hard copy and that's pretty much it really. A digital image on the other hand can be transferred into a computer and, with the right software, numerous improvements can be made. Colors can be increased or decreased, unwanted objects can be removed (including spots, wrinkles and the dreaded red-eye), new items can be inserted and special effects can be applied (see below).

The image sensors in the majority of digital cameras currently available are called Charge Coupled Devices (CCD). Another type, known as CMOS, is less widely used but gaining in popularity.

An image sensor is a complex piece of equipment that is powered by some extremely fancy technology. The sensors currently available are equivalent to an ISO film rating of 50–1600 in some models. The average is closer to 100-400.

The advantages of digital photography over its traditional counterpart are numerous and appealing:

Memory cards can be in a variety of formats. The type used will depend on the type of camera and each camera usually only uses one type of card.

- No more films to buy or process. A digital camera stores images on a reusable disc, or memory card, some of which can hold several thousand images before they are full

- You only keep the images that you want. You can delete unwanted images immediately after you have taken them or wait until you have a chance to review all of the pictures you have taken in that session

- Image editing software allows you to become a picture editor and a graphic artist

- Indexing programs, or operating systems such as Windows XP or Mac OS X, allow you to catalog your images on your computer

- Greater versatility in what you can do with digital images. They can be stored electronically, printed, sent around the world via email or viewed in your living room through a slide show on your television

The next generation of image sensors are known as Foveon X3. These capture a much greater range of color information than CCD or CMOS sensors and they are the first full color image sensors. Currently they are only present in top end cameras, but it is only a matter of time before they are more widely available. For more information, look at the Foveon website at: www.foveon.com

- Improved options for printing images. It is now possible to print out high quality images on consumer photo printers and also have them printed at photo kiosks or online

- Greater functionality in digital cameras. Digital cameras have now reached a stage of development where they operate in a very similar way to film cameras. This includes compact cameras and now also the more advanced SLR cameras

- Greater number of devices capable of capturing digital images. There is now a wide range of cell phones that are capable of taking digital pictures, which gives increased mobility for the digital photographer. This is one area that is set to develop significantly in the future

Digital drawbacks

However, as with every type of emerging technology, there are some drawbacks to the digital photography revolution:

Digital photography is not a cheap hobby.

- Set-up costs. The minimum needed to produce and edit digital images is: a digital camera, a computer, editing software and a printer. The printer could be optional if you are only using images on the Web but most people would consider it a necessity. Added to this there are items such as scanners, CD writers and storage devices. On the plus side many people may have some of these items already and so they are half way there. If you already embrace a digital lifestyle, then you will probably be well placed to make the most of digital photography

Do not be put off by the purists of the photography world who reject digital photography as a gimmick that will not last. These are the same type of people who claimed that the Internet would not catch on.

- Printing costs. Photograph-quality paper and ink are not cheap and on top of this is the wear and tear on your printer. Some of this is offset by the fact that you will only want to print your best images and you can discard any images that are not up to scratch. Initially, it may seem that digital photography will drastically reduce your photographic processing bill, but this is not always the case. However, in-store and online printing is getting more economical all the time and this is now a very cost-effective way of obtaining prints

- Complexity. Some areas of digital photography can be quite daunting at first. However, a good basic grounding can be picked up reasonably quickly and you do not have to be either a photography or a computer expert to produce excellent results with a digital camera

- Emerging technology. Digital photography is taking an increasingly firm hold in the consumer market and the development of the technology is moving very quickly. So what is cutting-edge today may seem obsolete in a year. However, if you keep waiting for the technology to advance and the prices to drop you never feel the time is right. Take the plunge now and be prepared to upgrade as time goes by. If you do, don't go back and look at the price of your equipment in six months

Differences between film and digital

As mentioned on page 9, in place of traditional film, a digital camera uses a device known as an image sensor to capture images once the light passes through the lens. In the majority of digital cameras, this sensor is known as a Charge Coupled Device (CCD). A CCD is made up of thousands of photosites that capture colors as the light passes through the lens of the camera. The colors are contained in pixels (see page 14). The pixels are processed by the CCD and this information is passed onto the storage medium within the camera. As with most things, different CCDs vary in quality and, in general, the best CCDs are in the most expensive cameras. This is one area that is being developed continually. The most important details about an image sensor are the quality of the pixels and the size of the pixels. For instance, the pixels in a professional digital SLR camera are a lot larger and of a higher quality than those in an inexpensive compact digital camera.

In addition to CCD image sensors, there is another variety, known as CMOS (Complementary Metal Oxide Semiconductor) sensors. Traditionally, these types of sensors were cheaper than CCD ones, but they produced an inferior image quality. This has now changed and CMOS sensors are being used more in high-end cameras and they are deemed, in some quarters, to produce superior images.

Whatever the type of sensor in a digital camera, it acts in a similar way to film in that it is the medium for collecting light as it passes through the camera lens. There are then various basic editing functions performed on the image before it is sent to the memory card for storage. This includes converting it into a suitable digital file format (usually a JPEG), correcting the white balance and sharpening the image.

One of the main differences between a digital camera and a film one is that it is possible to change an image sensor's sensitivity to light between shots. This is known as an ISO rating (also referred to as film speed) for traditional film and since each film has its own ISO rating it is not possible to change it without changing the film. However, with digital this can be changed continually from shot to shot and so it is ideal for capturing images in different lighting conditions. For more information on film speed and lighting issues see Chapter Four.

Using digital images

Printing images

One area of digital photography that has advanced significantly in recent years is printing images, in the home, in-store and online. Consumer inkjet photo printers are affordable and offer stunning results, almost to the point where the images are indistinguishable from those produced commercially. In addition to this, in-store and online printing now uses technologies that can print images to as high a standard, if not higher, than those for traditional film prints. The days of worrying about the quality of prints for digital images are now well and truly over.

Digital images are ideal for emailing to friends, family and colleagues over the Web. Simply create your email, then attach the image (the Attach function is usually denoted by a paperclip icon or something similar) and send.

Emailing images

One of the main uses of digital images is for emailing to friends and family. When emailing images a few common rules apply:

- Don't use images that are very large in terms of file size as these will take longer to download than smaller files

- Give images specific filenames so that the users can identify them quickly

- Don't send images that you don't want other people to see: with email it is very easy to forward images to large numbers of recipients

Companies that offer online image sharing usually also have a facility for ordering prints from digital images. These can also be produced on a variety of gifts such as mugs or T-shirts.

Sharing images

The explosion of interest in digital photography has spawned a number of related services and one of these is online companies that allow people to share their digital images over the Web. Users are allocated a certain amount of space and they can then upload their images onto their own individual area. This remains private, unless the user wants to invite other people to view their images. This then creates an online community. Most sites allow users to create several communities, so it is possible to have different ones for different groups of friends or family. These services are usually free (registration is required though) and it is becoming increasingly popular for people to share their images over the Web.

For more information about online sharing and printing services, see Chapter Twelve.

Understanding pixels

The technology behind digital photography is undoubtedly complex. Although there is no need to fully understand the inner workings of a digital camera, it is important to know a bit about the overall process of creating a digital image.

Images created with pixels are known as bitmap images. This is because each pixel (bit) is mapped to a grid which is then used to determine its position within the image. Another type of image is a vector graphic which is created from mathematical formulae. Photographic images are almost always bitmaps.

Pixels: the digital building blocks

If you are involved with any form of digital imaging it will not be long before you encounter the word pixel. This stands for picture element and it is the foundation upon which every digital image is built. A pixel is a tiny square of color and a digital image is made up of hundreds of thousands, or even millions, of these squares. If you enlarge a digital image enough it will become pixelated, which means you see each individual pixel rather than the overall image. Since pixels are so small though, once you view the image from a reasonable distance, all of the pixels merge to form (ideally) a sharp and clear image.

When a digital photograph is taken, the light captured by the image sensor is converted into pixels, with each pixel representing a certain color. In general, the more pixels that you have in an image the sharper it will appear. It is easier to get rid of extra pixels than to add new ones.

Using image editing software it is possible to enlarge an image and then change the color attributes of individual pixels, if you so desire.

1 When an image is viewed 1:1 it should appear sharp

Each pixel represents a single color, so for subtle color changes it is best to have as many pixels as possible. This creates the most accurate color representation.

2 When it is enlarged it becomes pixelated – each individual pixel can be seen

Resolution overview

Types of resolution

The first thing on a specification list for a digital camera is usually the resolution. This records the number of pixels in an image and can be specified in three ways: by its dimensions in pixels, e.g. 640 x 480; the total number of pixels in an image, e.g. 307,200 pixels; or the megapixel value e.g. 5 megapixels, which is an overall pixel count of 5 million. In general, the greater the number of pixels in an image, the better the quality. However, more pixels mean larger file sizes. The stated resolution of a digital image is not the physical size of it – this is determined by altering the image resolution in the image editing software. So an image with a resolution of 640 x 480 pixels (see below) could be displayed or printed with different dimensions, but the bigger the physical size, the poorer the quality of the image. This is because each pixel would have to be stretched to cover the greater area.

Some digital cameras give resolutions in interpolated values. This is a process whereby the camera adds pixels to the image. This increases the resolution (i.e. there are more pixels in the image) but it does not necessarily increase the quality accordingly. Look for cameras that offer optical resolution figures i.e. the actual physical number of pixels that they are capable of capturing.

When looking at the overall pixel count of a digital camera, ask about the effective pixel count, rather than just the headline figure. The effective count is the number of pixels that are used to make up the actual image. This is usually less than the headline figure since some of the pixels are required by the camera for calibration and image processing functions.

Most entry-level digital cameras have a minimum resolution of 640 x 480 pixels and at least two or three further options up to the highest resolution of the camera. Currently, entry-level digital cameras have a highest resolution of at least 3 million pixels (3 megapixels). The top of the range consumer cameras are currently capable of capturing over 8 million pixels in a single image. Understandably, the price of the camera increases with the number of pixels that it can capture but it is worth going for the best one you can afford. One consideration in relation to this is how you are going to use your images: images on the Web can be a lot smaller than those being used for printing.

Image resolution

When it comes to outputting an image, the resolution in terms of pixels per inch is the important consideration. A lot of digital cameras automatically save images at 72–96 ppi. This means that if the image was viewed on a monitor or printed on paper there would be 72 or 96 pixels in each linear inch. So if the number of pixels in the image was 1280 wide and 960 high then this image could be produced at a size of 13.3 inches by 10 inches (1280 divided by 96 and 960 divided by 96). The final quality of the image will depend on the type of output device that is being used.

Resizing an image

The resolution of an image can be set from within the image editing software. Once this has been done the resolution remains the same, regardless of the type of output device being used.

In most editing packages, when you change the resolution of an image this does not affect the on-screen view. If you want to change this you can do so by changing the magnification or, in some programs, the canvas size. Also, changing the image resolution does not change the size of the file, it just means that the pixels will be closer together or further apart when printed.

Changing an image's resolution in an editing program alters the output size

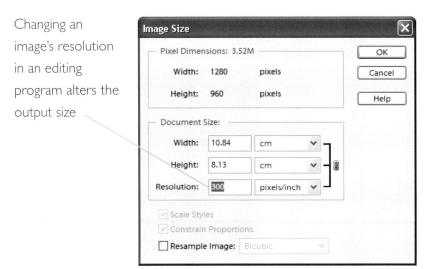

Changing the resolution of an image changes the size at which it will appear once it is printed or viewed on screen. If, in the example in the first paragraph, the image resolution was 300 ppi then the image would be output at a size of 4.3 inches by 3.2 inches (1280 divided by 300 and 960 divided by 300).

The size of images can also be changed by using a process called resampling. This involves the software adding more pixels to the image using a method of electronic guesswork. This creates a bigger image but with lower quality.

Monitor and print resolution

The issue of resolution becomes important when you want to display your images because it affects the size at which they can be viewed satisfactorily. The two main areas are displaying online and printing hard copy.

Of the two, using images on the Web is the more straightforward. Most computer monitors display images at 72 or 96 ppi so an image that has a resolution of 640 x 480 pixels can be viewed at a size of approximately 9 inches by 6.5 inches. (This is calculated by dividing 640 and 480 by 72.) If you want a larger image then the quality will decrease slightly because each pixel will have to increase in size to cover the extra area.

It is possible to get very good print quality with a print resolution of 150 ppi, and even 72 ppi can be acceptable. However, for the very best quality, aim for 300 ppi, if the overall size of the image allows for this. If the image is too small for the required output size at the selected print resolution, then a lower resolution will be required.

When digital images are printed as hard copy the same calculation can be applied – the dimensions of the image (in pixels) divided by the resolution set in the image editing software (this is sometimes known as print resolution and can also be thought of as the output resolution). The best output image resolution setting for color inkjet printers is 300 ppi as this gives the best output quality. So to print an image with the dimensions of 640 x 480 at a resolution of 300 ppi the resulting size would be:

640/300 = 2.13 inches

by

480/300 = 1.6 inches

The printer resolution is the number of colored dots that the printer can put on an inch of paper; print resolution determines how many pixels are placed within each inch. So if the print resolution is 300 ppi and the printer resolution is 2880 dpi, each pixel will be printed by 9.6 dots of color (2880 divided by 300).

By anyone's standards this is small for a printed photograph. You can increase the size by setting your output image resolution to 72, but this would result in a lower quality of picture because 72 colored dots in an inch are a lot less tightly packed than 300. So if you want to take digital images for printing hard copy then go for a camera with as high a resolution as your budget can stretch to.

The best way to see how printers handle digital images is to get a demonstration from a retailer. If possible take one of your own images for them to use rather than the pre-installed ones in the shop. This way you will see a truer result for your own needs rather than relying on an image that is designed to show the printer in its best light.

A whole book could be written on the topic of pixels and resolution, and they have been, but the main points to remember are:

"Resolution" is a popular term in the imaging world and is also used in relation to monitors and printers. Make sure you know what is being referred to when you hear the word "resolution".

- The more pixels in an image, the better the quality will be from the output device

- When calculating the physical output size of your image, divide the number of pixels across (or down) by the output image resolution (also known as print resolution) set within the image editing program

- For images that are going to be displayed on the Web, set the output resolution to 72 or 96 (ppi)

- For images that are going to be printed, set the output resolution to 300 (ppi)

A printed image will always look better on high quality photographic paper than on standard multi-copy paper.

- Image resolution can be altered in the editing software

If an image is being viewed on a monitor then the size it can best be displayed at can be calculated by setting the output resolution to 72 or 96 (the resolution of the monitor)

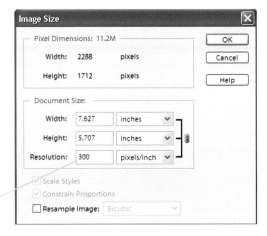

Try not to get pixels per inch (ppi) confused with dots per inch (dpi). Think of ppi in relation to images on a computer monitor and dpi in relation to images when they are printed out in hard copy.

If an image is being printed the output size can be calculated by setting the output resolution to 300 (the ideal resolution for printing)

Image compression

One of the most popular photographic file formats, JPEG (Joint Photographic Expert Group) has been designed so that it handles compression well. This means that it produces good quality images while maintaining small file sizes.

Most digital cameras offer a variety of compression settings when an image is being captured. This involves creating a smaller sized image file by discarding some of the pixels that the camera decides are superfluous. This inevitably leads to some loss of image quality but more images can be stored when you are taking pictures. Typically, digital cameras have compression settings along the lines of Good, Better, Best. These refer to the final quality of the image – Good is the most compression and the lowest quality, Best the least compression and the highest quality.

The amount of compression used will depend on what the image is going to be used for:

- An image for a website does not have to be of a high resolution so this can be taken on maximum compression

Each time a JPEG image is opened and then saved it is compressed. This means that if a lot of editing is done to a JPEG image, the overall quality can deteriorate.
If this is the case, perform the editing in an image format that does not use compression (such as TIFF) and then save the final version as a JPEG.

- A image that is going to be printed as a hard copy will be required to be of the best resolution available and so minimal or no compression should be used

Although the idea of compression sounds like a drawback as far as the quality of printed images is concerned this is not necessarily the case. With the naked eye the quality of a moderately compressed image is little different to that of one with no compression.

The amount of compression affects the overall file size of an image and this in turn determines the number of images that can be stored on a camera's memory card. So if an image has no compression, it will be larger in file size than one that has the maximum amount of compression applied to it. This can be a factor if you do not have ready access to a computer to download your images once they have been captured (for instance, if you are on holiday). In cases like this it may be necessary to increase the amount of compression in order to store more images on your memory card.

A newer file format, PNG (Portable Network Graphics), is similar to JPEG but is not as widely used.

When determining the size of images being captured by a digital camera the level of compression and the resolution are the two major factors. Both of these can be altered to change the overall quality and size of individual images.

Color models and color depth

In top-of-the-range image editing programs, the RGB model is broken up into the individual colors, also known as color channels. Each channel can then be edited independently of the others.

Color models

The color in a digital image is based on the RGB (Red, Green, Blue) color model. This is the method of creating colors that is used by both digital cameras and computer monitors. To achieve the color that the human eye sees, an RGB device mixes red, green and blue to produce the final multi-colored image. This can produce images with up to 16 million colors in them.

Although digital cameras and computer monitors use the RGB color model, printers use the CMYK (Cyan, Magenta, Yellow, Black) color model. This is because color printers are not able to reproduce all of the colors that the RGB model can since ink is not as pure as natural light. Therefore black (the K in the CMYK color model – not B in case this is confused for blue) is used to create pure black and also correct any color variations. As far as converting an RGB image into a CMYK hard copy is concerned, this is usually taken care of by the printer software.

When calculating file size, it is worth remembering the basics of file measurements:

8 bits = 1 byte
1,024 bytes = 1 kilobyte (1K)
1,024 kilobytes = 1 megabyte (1Mb)
1,024 megabytes = 1 gigabyte (1Gb).

Color depth

The quality of the color in a digital image depends on the number of bits that are used to make up each pixel. A bit (short for binary digit) is the electronic representation of either 0 or 1. Each bit in a pixel is used to store important data about the color of that pixel: the more bits, the more information stored and so the final image is of a higher quality. The number of bits used to make up a pixel of color is known as the bit depth and there are two main choices:

- 8-bit, which gives a total of 256 colors (2 to the power of 8)

- 24-bit, which gives a total of 16.7 million colors (2 to the power of 24)

The higher the bit depth of the image, the larger the size of the image file. File formats that are designed for specific purposes have different bit depths: a GIF file, which is used for Web graphics, is an 8-bit (256 colors) format while a JPEG format (commonly used for digital photographs) is a 24-bit (16 million color) format. The color depth of an image does not affect the overall number of pixels in it: a 24-bit image with 1 million pixels still has the same number if it is displayed as an 8-bit image.

Equipping yourself

Knowing what you need to take effective digital photographs can be a daunting prospect at first. This chapter shows you the equipment that you will need and some of the areas to consider when you are buying it.

Covers

Chapter Two

Looking at digital cameras

At first sight the range of digital cameras is both dazzling and bewildering. Some of them look like conventional compact or SLR cameras, while others resemble something out of a science fiction series. As yet there is no standardized design for digital cameras so the first thing to say is, forget what it looks like, make a close inspection of what it does. If it looks sleek and shiny, but does not do the job you want it to, then move on to another model.

The price range for digital cameras is considerable (probably greater than for traditional film cameras), but there is something that is now affordable for every level of digital photographer, from the casual image taker to the professional. Before taking the plunge it is important to ascertain what it is you are going to be using a digital camera for. Some of the options include:

Digital cameras are prime candidates for retailers who like to push extended warranties with their products. If you do want this type of service it is usually cheaper to get it from a specialist insurance company.

- Capturing images for display on Web pages

- Online distribution via sharing services and email

- Using images for business presentations

- Printing medium-quality snapshots

- Printing high-quality prints

- Creating publication-quality documents

Each of these options will require a different specification from the camera. For Web images, and on-screen presentations, an entry-level model would suffice (although you may want a higher specification if you are going to print your business presentation in hard copy) while the higher the print quality you require, the more advanced the camera will need to be.

Some digital camera makers pride themselves on trying to produce the smallest digital cameras on the market. While this is a considerable technological achievement, it is not always the best option for the user: small cameras can be harder to use effectively (lenses can be obscured by fingers) and they can be lost more easily.

It is easy to become dazzled by the sheer volume of gadgetry associated with digital cameras. The devices themselves are beguiling objects and it is possible to let your heart rule your credit card when it comes to buying one. Before you make a choice, take some time to assess your needs in relation to the options on offer.

It's more than just a camera

When you buy a digital camera you will discover that it consists of a lot more than the camera itself. There will also be:

- Some form of transfer device to get the images into the computer. In some models this is done by connecting the two devices by cables. However, in more recent models this has been superseded by memory card readers of various descriptions or even infrared transmission

- Software to edit the images. The standard of these is usually proportionate to the price of the camera but even the entry-level models have software that is perfectly adequate for general image editing

If you are using an operating system on your computer such as Windows XP or Mac OS X, images can be downloaded very efficiently with a USB (Universal Serial Bus) cable connection.

Digital photography uses a variety of accessories, some essential and others only desirable

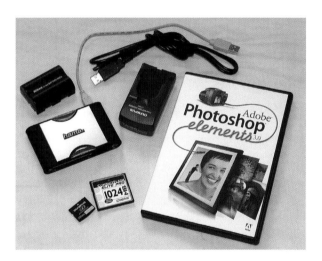

All of the above are important for the overall imaging process so it is worth examining closely what different models offer. Discuss with your retailer the pros and cons of various models, and if they are not prepared to spend time with you then go somewhere else.

Researching the options

Because of the diverse range of digital cameras on offer, and the different uses for them, it is essential to do some research into the subject before buying one or upgrading. Luckily there is plenty of help at hand when looking into the varied world of digital cameras:

One area of research that is often overlooked is asking people who use digital cameras. If you do this, try and find two or three users so that you can get a good overview.

- Camera magazines. Traditional photography magazines are slowly beginning to realize that digital photography is here to stay and more features on this area are starting to appear. In addition, they are also useful for general photography tips which can be applied equally well to digital photography

- Computer magazines. General computer magazines frequently carry articles on digital photography including reviews of new products. It is best to read at least two or three different publications to get a balanced view

PC magazines are also a valuable source of information about items such as printers, scanners, storage devices and software.

- Consumer magazines. Magazines such as Consumer Reports periodically review the latest digital products and it could be worth keeping an eye out for these. They have a website at www.consumerreports.org although there is a subscription fee for some services

- The Internet. The Web is an ideal source of information on digital imaging. A good way to start is to enter "digital photography" or "digital imaging" into an Internet search engine. There are several online magazines that offer up-to-date news and reviews. Some websites to try are www.pcphotomag.com, www.digitalcamera.com and www.pcmag.com (this is a general PC magazine but it carries a lot of digital imaging features). Also, the websites of the major digital camera manufacturers

There are a lot of very useful sites on the Internet that provide reviews of the latest digital image products, particularly cameras. Some to look at are: www.dpreview.com www.shortcourses.com www.lonestardigital.com

- Professional camera/computer stores. In general, smaller specialist shops are more willing to take the time to explain the subject than the larger electronics stores are. When you are actually buying a camera, ask to test all of the models in which you are interested

Considering computers

PC or Apple Mac?

If you are buying a new computer for digital imaging purposes then it is a matter of personal choice. Macs have traditionally been the favored platform for designers and graphic artists and they are well equipped to handle complicated image editing, particularly with their user-friendly iPhoto software.

Processor speed

It is a generally accepted fact in the computer world that what is a lightning fast processor today will be a deadly slow one tomorrow. To run most image editing software a minimum of a good quality Pentium chip (or Mac equivalent) is usually required. If possible, go for the fastest processing chip that you can afford. However, processor speed is not the only consideration when considering your computer's ability to process and store information. In some cases, a well set up computer with a slower processor can work more efficiently than one with a more powerful processor that has not been as well made.

RAM and hard drives

The two types of computer memory, RAM (Random Access Memory) and the computer's hard drive, are important to the digital editor for different reasons. The amount of RAM affects how quickly the computer will be able to process the image when it is being edited and the hard drive will determine the storage capabilities of the computer, for both the editing software and the completed images.

If you ask anyone who works with computers for the single most valuable upgrade for their system the chances are they will say RAM. It is fair to say that you can never have too much RAM, particularly if you are doing a lot of image editing (256Mb is a good starting point), which can consume large chunks of this valuable commodity. The amount of RAM not only affects the processing speed of your computer, it can also determine whether the machine crashes at regular intervals or not. If a computer is struggling for memory when processing an image it may decide to give up the challenge.

A computer's hard drive is used to store files and also the software that is put on the system. Some modern consumer computers

If you develop a liking for digital photography and then want to expand into digital video you will certainly require as much RAM and hard drive space as possible. Digital video is usually measured in terms of gigabytes rather than megabytes as far as file size is concerned.

come with enormous quantities of hard drive space – over 120Gb (gigabytes) in some cases. While it is unlikely that you will fill up that much in a short space of time it is nonetheless worthwhile trying to have as much hard drive memory as possible. There are three reasons for this:

- As you do more digital photography it is inevitable that you will want to add more software to your system and image editing software is invariably memory-hungry

- The more you experiment with digital images, the more you will acquire. Imagine if all of the photos lying around the house were to be transferred to your computer. Before long your hard drive will start filling up and there may come a point when you will want to investigate some of the storage devices looked at later in this chapter

- As you do more work with digital images you will come to have higher expectations from your computer

Flat screen monitors are becoming more popular with computer users and the CRT type of monitors have now been surpassed by the flat screen variety.

Monitor size

If possible, go for a 17 inch monitor or higher, but the bigger the better as far as digital image editing is concerned. Also, use a glare guard over your monitor to reduce eye strain.

Check the specification

Before you buy a digital camera, check the specification sheet that comes with it to make sure that your computer's operating system is compatible with the digital camera and also any image editing software that you intend to use.

If you try to edit digital images with a low-spec machine (i.e. 64Mb of RAM and a 2Gb hard drive), you may find that it is a very slow process and your computer crashes regularly.

As a guideline, these could be considered as the minimum specifications required from a computer when dealing with digital images. If possible, aim for the best you can afford:

- Pentium III processor (G4 on a Mac), 256Mb RAM, at least 40Gb hard drive

These can be seen as the minimum requirements to make the process enjoyable and reasonably stress-free.

Choosing a printer

Once the work of capturing, processing and editing a digital image has been completed it is time to look for an output device. If the image is being displayed on the Web then this solves the problem – the image merely has to be inserted into a suitable format and then published on the Web. During the whole operation the image never leaves the safe environment of the computer.

However, if you want to have a printed image of your endeavors, as most people do at some time, then you will need some form of printing device for outputting your image. Although the market for printing digital images is dominated by one type of printer, there are several options from which to choose:

As well as the printers there are also print consumables such as paper and ink to consider.

- Inkjet printers. This is by far the most common type of color printer for digital images. Inkjet printers are relatively cheap, easy to use and, given the right circumstances, can produce excellent near-photographic quality. The technology in this area is improving all the time and the output quality is getting better and better

There are now several printers on the market that accept flash memory cards. They are slotted into the printer and the images can then be printed. This is a considerable innovation because it allows for printing images without the need for a computer.

- Laser printers. Color laser printers produce good results but they can be expensive. Business use is the best bet for this type of printer

- Dye-sublimation printers. This type of printer produces a continuous tone image by welding colored dyes onto the paper by a heat process. It is generally accepted that dye-sublimation printers produce the closest results to actual photographic quality. However, some of the ones on the consumer market only produce small prints (either passport photo size or 5" x 4" approximately). Their other main drawback is that they can only be used for color printing, so you would need a separate printer for your textual printing needs. It is likely that this type of printer will become more and more popular in the near future

Some printer manufacturers, such as Canon, produce printers that connect directly to their own digital cameras.

- Micro dry printers. These printers use a similar process to dye-sublimation printers but use an ink-coated ribbon instead of dyes. They can also print text

Flash memory options

Most digital cameras currently use some form of removable memory (also known as flash memory), on which images are stored once they have been captured and processed through the camera. This is now a growth area of digital photography and there are an increasing number of removable memory options:

- CompactFlash. One of the market leaders in the removable memory sector, CompactFlash cards are used by a large number of digital camera manufacturers. They usually come in sizes of 32Mb to 8Gb but there are also some cards being developed that have an even greater capacity

- SmartMedia. The other main player as far as removable memory is concerned, SmartMedia cards come in similar sizes to CompactFlash but they are slightly smaller in physical size

- xD Memory Card. This is one of the smallest types of removable memory, but it has a high storage capacity and a fast rate of data transfer

- Memory stick. This is a versatile form of removable memory and it is used in a variety of devices including digital cameras

- SD Card. Another very small and light form of removable storage, the SD Card is gaining in popularity with some digital camera manufacturers

- Multimedia Card. Similar in size to the SD Card, the Multimedia Card is ideal for manufacturers who want to create ever smaller digital cameras

The type of removable memory will depend on the model of camera but CompactFlash and SmartMedia are the most common at the present time. These devices are relatively economical since they can be reused numerous times. However, they are very small and delicate so take good care of them. Occasionally, removable memory cards need to be reformatted and this can usually be done within the camera, either through the camera's menus or through the system software that is provided with the camera.

If you do not want to cable your camera into the computer to download your images, removable forms of memory need an adapter or a card reader in order to get the data into the computer. In some cases this is an adapter that can be inserted into your computer's floppy drive and in others it is a separate reader into which the card is inserted. Check carefully when you are buying a camera to see what type of removable storage it has and how its contents are downloaded.

Cable transfer

Once you have captured your images onto your camera's memory, you will need some method of transferring them onto a computer. There are two main options available: cable transfer or a card reader for use with a flash memory card.

 On most new computers the cable connection is through a USB (Universal Serial Bus) port which speeds up the downloading time considerably. If possible, try to use a computer with a USB connection.

Cable transfer can be used for on-board memory and also for removable flash memory. To conduct this method of transfer, a cable is attached to the camera and to a port on the computer. These days it is usually a USB connection but it can also be a serial one. The data is transmitted through the cable into the computer. However, this has two main drawbacks:

- It can be slow if a serial cable connection is the only one available

- It can be irritating to have to fumble around with yet more cables at the back of the computer every time you want to download images

 The two main makers of computer operating systems (Microsoft and Apple) have designed their latest operating systems (Windows XP and Mac OS X) to make downloading digital images as easy as possible.

Cable transfer can involve cramped spaces and a tangle of cables. (Some manufacturers try and get around this by placing the USB ports at the front rather than the back of the computer)

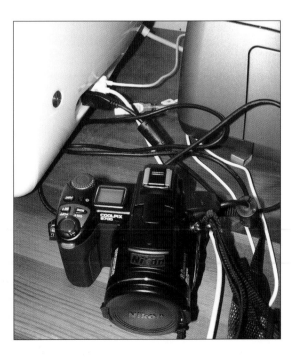

Card readers

Card readers can be connected to computers and then used to download images directly from a camera's memory card. They usually connect by a USB cable and can generate very fast download times. Once they are connected they show up as a separate drive on the computer, like a floppy disk drive. Once the memory card has been inserted, images can be accessed straight from the card.

There are several different types of card readers on the market and an increasing number of them are capable of reading a variety of different card types. These are known as multi-card readers and are an excellent option if you have two or more cameras with different types of cards. Also, it means that when you buy a new camera you do not have to worry about whether the card will work with your card reader. Multi-card readers usually accept all of the major types of flash memory cards currently available. Each available slot shows up as a separate removable drive on your computer and it is simply a case of selecting the drive that currently contains the card and downloading the images from it.

Multi-card readers are an inexpensive way to access a variety of flash cards and they take a lot of the hassle out of downloading images onto a computer

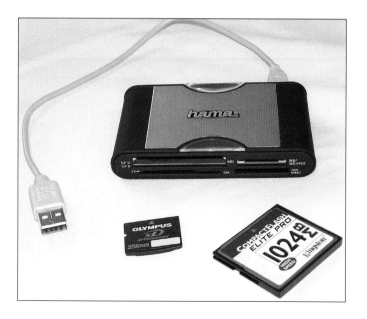

Image editing software

Technically, it would be possible to capture digital images and print them out without ever introducing image editing software into the equation. However, you would not be able to amend or manipulate your images, so one of the main assets of digital photography would be lost.

Image editing software allows you to edit the color attributes of an image, add your own text or graphics, apply touch-up techniques and incorporate them into designs such as greetings cards, gift tags or posters.

The bad news about imaging software is that it can be expensive for the most sophisticated programs. But the good news is that there are numerous entry-level programs that give an excellent introduction to the subject. Even better, all digital cameras come with some type of imaging software. Some even come with the top-of-the-range packages.

Professional programs

The accepted market-leader for professional image editors is Adobe Photoshop. This does everything you could ever want from an imaging package and more besides. However, for the novice it can be quite daunting to use: it is best suited to people who have some prior experience of the digital imaging world. Having said that, there is certainly nothing to touch it as far as versatility, functionality and quality are concerned.

Programs such as Adobe Photoshop are excellent for image editing, but at first sight they can be a confusing collection of menus, toolbars and icons

Entry-level programs offer every assistance during the editing process. Take some time exploring the Help features and going through the online tutorials.

Entry-level programs

While entry-level imaging programs do not offer the finesse of their professional cousins, a lot of users will not miss these subtleties. A lot of less expensive programs still offer color controls, special effects and touch-up techniques. With very little experience it is possible to create digitally enhanced images that will have people thinking that you have been doing it for years.

The great advantage of these programs is that they are very user friendly and guide the novice user through the whole process of digital imaging with the aid of icons, help assistants, templates and wizards.

Some good quality free image editing programs can be downloaded from the Web. One of the best sites to try is CNET at www.cnet.com

Another feature is the variety of uses you can make of your images with these programs. In addition to merely enhancing them you will be able to create cards, posters and invitations incorporating your favorite images and also email them to friends and family via your image-editing program. With some programs you can also create slide shows, print images for T-shirts or design your very own personalized mug. The emphasis with these programs is to make image editing as easy and hassle-free as possible. But most of the programs still manage to pack in an enormous number of functions.

In some entry-level programs, the editing functions are controlled by selecting the effect that you want through an icon and then dragging and dropping it into the image to be edited.

An entry-level editing program can offer powerful editing tools and also various help functions and tutorials

Storage devices

As you collect more and more digital images there will probably come a point when you will want to store them on something other than your computer's hard drive. There are two reasons for doing this:

- Purely for back-up, in case your hard drive fails

- In order to free up space on your hard drive for your other computing needs

Floppy disks

Most computer users are familiar with floppy disks. They are cheap, straightforward to use and relatively robust. But for digital images they are not ideal. This is because they only hold a maximum of 1.4Mb of data. This is enough to hold a few low resolution, high compression images but for anything much bigger they are too small.

If your computer only has one parallel port and your printer is already connected to it, you can cable the printer through the Zip drive. Detach the printer cable and attach it to the connector at the back of the Zip drive. Then connect the Zip cable to the computer's parallel port.

Zip drives

One of the success stories of computer storage in recent years has been the Zip drive. This is similar to a floppy disk drive, except that the disks hold 100Mb of data. This is for the standard model and there are options that offer up to 1Gb of storage. Zip drives can be internal or external. The external version is connected with standard cabling to a parallel port (or, increasingly, a USB connection) at the back of the computer. A recent addition to this range is a 250Mb Zip drive. This can also read 100Mb disks, but the 100Mb drive cannot read the 250Mb disks.

Pen drives

A more recent addition to the removable storage market is the pen drive. This is a small device that is capable of holding 128 or 256Mb and it connects via a computer's USB port. This means that images can be loaded onto the pen drive and then transferred quickly onto another computer. The small size of pen drives and the ease with which images can be transferred make them ideal for use with digital images. The capacity and flexibility of the pen drive is starting to make media such as floppy disks and zip drives seem slightly old fashioned and this certainly seems the way forward for removable storage.

CD Writers come in both internal and external varieties. The type that you choose may depend on your ability to fit it internally and the amount of space on your desktop.

CDs that can only be copied onto once (CD-R) are cheaper than the ones that can be reused numerous times (CD-RW). Both are cheaper if you buy in large quantities.

The process of copying a CD is known as "burning". This is done with a CD writer and the appropriate software. To try to avoid wasting discs, burn CDs at the lowest speed that your CD writer will allow (e.g. 1X or 2X). This will give the software more time to transfer the data and there is less chance of a disruption in transmission causing the process to fail.

DVDs (Digital Versatile Discs) are also becoming more common for storing photographic images. They contain up to 4Gb of data and a DVD writer is required in order to be able to burn DVDs.

CD-ROMs

CD-ROMs offer 650Mb of data storage and this option is becoming increasingly popular. Images on CD-ROMs can be created by a professional bureau, or you can create your own using a CD writer. This is a device that transfers images (among other items) from your computer onto a CD-ROM. This is an area that is developing quickly and is becoming more and more popular with users.

Initially it may appear that a CD's 650Mb of storage space is an enormous amount and you will only ever need one CD. But while a CD has approximately 430 times the storage space of a humble floppy disk, you will be amazed at how quickly you fill one up. As your digital photography repertoire expands so will your collection of images. It is a harsh fact of computer storage life that there is no such thing as too much storage capacity.

One important issue with creating your own CDs is format. Some CDs can be copied as read-only (CD-R) which means you cannot erase any data from them and you cannot reuse them once they are full. The other format is rewritable (CD-RW) which means you can delete or copy over items that are already on the disc. This gives you more versatility but there is also the risk that you could record over an image that you wanted to keep. Also, since CD-RWs have come onto the market more recently, some older CD-ROM drives cannot read them.

Archiving images

The best way to archive digital images is on a CD or a DVD. The current archival lifespan for the range of CDs and DVDs on the market is anything from 30 years to 100 years. This is because the coating on the discs can deteriorate over time. However, the data on the discs can always be copied again in a few years' time and with the advances in technology it is likely that within a decade there will be a new form of storage for archiving digital data.

CDs are an excellent way to save and keep your images. Don't underestimate the importance of this – in 100 years' time your descendants will appreciate the fact that you took the trouble to archive your images.

Accessories

If you are one of those people who believe you will never get caught up in the giddy world of accessories and peripherals, then think again. Digital photography is a magnet for add-ons and extra gadgets and in this respect it could give the computing world a run for its money. Some of the items that you may want to consider to satisfy your craving for more accessories are:

The RadioShack stores offer a wide range of digital photography equipment and accessories. They also have an online store at www.radioshack.com

- A camera bag. This could be seen as a necessity rather than an accessory (when you start thinking like this then you know you really are hooked). If you have bought a delicate piece of technology for several hundred pounds then it makes sense to try and keep it as secure as possible. Some models come with their own bags, but if you want something a bit sturdier then try a specialist camera shop

- A tripod. This is a standard piece of equipment for some photographers, while others do not consider it necessary for their type of photography. As a rule, if you would use one for traditional photography, then do so for the digital variety. With the increase in availability of SLR digital cameras, the need for tripods could be increased

If you are going to be using a tripod a lot it is a good investment to buy a sturdy one. They can undergo a fair amount of wear and tear during normal photographic duties.

A good quality tripod is a worthwhile investment for a digital photographer, particularly when taking images at slow shutter speeds, such as at night or in dimly lit situations. The best way to test a tripod is to press down on its neck and see if it remains firm and stable

- Extra memory cards. At least one card is usually supplied with the camera but it is always a good idea to have a spare one. This can come in useful if your working card becomes full or damaged. It can also be very useful if you do not have ready access to a computer

A battery charger and rechargeable batteries. As soon as you start using a camera with an LCD (Liquid Crystal Display) you will realize the importance of a battery charger. These mini screens use up batteries at an enormous rate and a recharger could save you from buying batteries by the truck load. Even so, always make sure you carry at least one spare set of batteries with you

If you invest in a battery charger then you will save a lot of money on new batteries. However, it still costs money to recharge the batteries and this can take up to eight hours for a standard charger. High-end chargers can do the job in half that time.

Additional lenses. With some digital cameras it is possible to get lens attachments, such as you would fit on a standard SLR (Single Lens Reflex) camera. These include close-up lenses, wide-angle lenses and telephoto lenses

Cleaning equipment. It is good practice to clean your camera and if done correctly it will certainly not do it any harm. One simple but useful item is a lint-free cloth. This can be used to clean the LCD panel, which has a habit of smearing easily

Cleaning equipment can include a lint-free cloth, a lens cleaner, an airbrush, cotton buds and a bottle of cleaning fluid

If you are well and truly bitten by the accessory bug then it will be a costly habit and one that is hard to break. But at the same time, it will give you a lot of fun.

Buying accessories

It pays to shop around for all items related to digital photography and this is particularly so with accessories. Due to the nature of the medium these are now appearing in photographic stores, computer stores and also general electrical stores. Look for the best price and also the best service. If you can build up a good relationship with a retailer of digital accessories then this may come in useful in the future.

Buying a digital camera

This chapter sets out some of the things to look for when you are buying a digital camera. It also looks at some of the other items associated with digital cameras.

Covers

Chapter Three

Price and range

At the early stage of their development, the price of digital cameras was a major deterrent to many people buying them. However, this has now changed dramatically, to the point where good quality digital cameras are now affordable for most people. In addition to this, top-of-the-range digital models, such as digital SLR cameras, have fallen even more steeply in price. They are now affordable for professional and serious amateur photographers and very much a realistic option.

Although digital cameras may not always be displayed in the following categories in retail outlets, the three main general groups of digital cameras are:

- Consumer

- Mid-range

- Professional

Some digital cameras also double up as Webcams, which can be used to send pictures and video over the Internet.

Consumer cameras

These are the mostly widely available type of digital camera currently on the market. A lot of them offer excellent quality and they are more than adequate for all but the serious amateur or professional. Some of the general characteristics of consumer digital cameras are:

- Compact

- Overall pixel count per image of between 3 million and 5 million pixels

- Fixed focus or some form of zoom lens

- Built-in flash

- Extras such as sound and video recording

- Limited manual settings

Mid-range

Mid-range digital cameras are those that are aimed at serious amateurs who want to have more control over their cameras than they can with a standard consumer one. Some of the general characteristics of mid-range digital cameras are:

Some mid-range digital cameras to look at include the Canon Powershot G6, the Minolta Dimage Z5 and the Nikon Coolpix 8800.

- Usually compact but some models have a facility for adding lens attachments to the existing lens

- Higher quality lens and CCD image sensor than found on consumer cameras

- Wider range of zoom lens

- Overall pixel count per image of between 5 million to 8 million pixels

When looking for mid-range or professional digital cameras it is better to stick to traditional camera makers such as Kodak, Nikon, FujiFilm, Canon, Olympus, Minolta or Ricoh. This is because they have more experience of producing high quality camera bodies and a wider range of manual controls.

- Wide range of manual controls, such as those for exposure, color adjustment, shutter speed and white balance

- Wider range of file formats for saving images within the camera

- ISO equivalent range of approximately 100–1600

Professional cameras

These are digital SLR (Single Lens Reflex) cameras that are becoming used more widely. Some of the general characteristics of digital SLR cameras are:

- Interchangeable lenses

- Top quality lenses and image sensors (both CCD and CMOS)

- Overall pixel count per image of 6 million pixels and upwards

- Range of manual controls

Compact versus D-SLR

In the early days of digital photography there were some digital SLR cameras (high specification cameras with interchangeable lenses). However, these were prohibitively expensive for all but the most serious, and affluent, photographers. But this has changed dramatically in recent years and there is now an affordable range of sub-$1000 digital SLR cameras. This raises the question of whether it is worth buying a digital SLR (D-SLR) or a compact digital camera. In some respects it depends on what you want to use it for: if you just want to take a few snapshots of the family then a compact will more than cater for your needs. However, if you want better quality images or are interested in developing your photography skills then it is definitely worth looking at a D-SLR.

Some of the advantages of using a D-SLR are:

Canon and Nikon are the market leaders in the D-SLR world: have at look at the Nikon D70 and the Canon 350D Digital Rebel XT for top quality, affordable D-SLR cameras.

- Better image quality. Digital SLR cameras have larger image sensors than compact ones so the pixels captured by a D-SLR are larger than their compact counterparts. This means that a 5 megapixel image from a D-SLR will be of significantly better quality than a 5 megapixel image from a compact

- Greater functionality. D-SLR cameras offer more options for capturing images and being creative with your photography. While this may not be an issue if you simply indulge in point-and-press photography, it is invaluable if you want to start getting a bit more out of your camera. However, D-SLRs can also be used as high quality point-and-press cameras

- Improved ease of use. Despite the fact that D-SLR cameras have greater functionality than their compact cousins, this does not necessarily mean they are complicated to use. In a lot of cases the reverse is actually true. This is because most of the controls on D-SLR cameras are accessed from the camera body rather than a series of menus through the LCD panel. For instance, if you want to change from Aperture mode to Shutter mode on a compact camera you may have to scroll through two or three in-camera menus. However, on a D-SLR it is usually just a case of twiddling one dial and the change is made instantly

- Fewer time delays. Among the drawbacks of compact digital cameras are time delays (see page 46 for full details). The main ones are the wait when the camera is first turned on, the time lag between the moments when the shutter is pressed and an image is captured, and the recycling time between one shot being taken and the camera being ready for the next shot. D-SLRs are ready for use almost instantly once they have been turned on, the time lag is a lot less because of the internal mechanism of this type of camera, and they are designed with a buffer system that allows an image to be captured while the previous one is still being saved

- Greater flexibility. Since lenses on D-SLR cameras are interchangeable, you have almost unlimited opportunities for high quality and creative photography. As with everything, some lenses are cheaper than others, but it is worth investing in good quality ones as this will make a difference to the range of images that can be captured with a D-SLR camera

Digital SLR cameras are not for everyone, but if you have an interest in photography and want to capture high quality images and develop your skills then they are definitely worth having a look at.

Digital SLR cameras have become increasingly affordable and offer great opportunities for anyone who wants to capture great pictures or take their photography to the next level of expertise

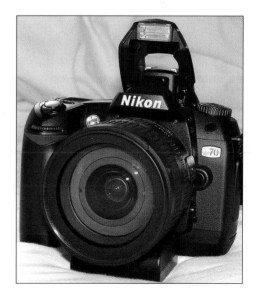

Camera modes

Most digital cameras on the market allow for a certain amount of flexibility when capturing images. One of these areas is changing the aperture and shutter speed of the camera. The standard modes that are on offer for this are:

Auto

On this setting the camera determines the aperture and shutter speed automatically, depending on the amount of light that is coming through the lens. This is the basic point-and-press mode, where the camera takes full control of the process of capturing the digital image

Aperture priority (A)

Aperture refers to the amount a camera's lens diaphragm opens and closes. This determines how much light gets into the camera. Aperture is measured in f-stops or f-numbers. A small f-number, e.g. f 2, means the lens is wide open so a lot of light gets into the camera. A large f-number, e.g. f 22, means the lens opening is very narrow and only a small amount of light gets in. If the camera is set on aperture priority mode you can set the aperture and the camera will automatically select an appropriate shutter speed. Aperture mode is usually used when you want to change the depth of field of an image, i.e. the area of the image that is in focus.

Shutter priority (S)

The shutter speed is the speed at which a camera's shutter opens and closes. Shutter speed is measured in fractions of a second and is the length of time that the shutter is open to allow light to pass through the lens. A standard shutter speed is 1/125th of a second. If the camera is set on shutter priority mode you can set the shutter speed and the camera will automatically select an appropriate aperture. Shutter mode is usually used when you want to freeze fast moving objects or create a deliberately blurred effect such as with moving water.

For a shutter speed of approximately 1/30th of a second or slower, use a tripod, otherwise you will not be able to hold the camera still enough to avoid a blurred image as a result of camera shake.

Manual (M)

If a camera has a manual mode then this allows you to set both the aperture and the shutter speed. This is generally used in difficult lighting situations where the camera cannot expose the image correctly. Manual mode requires a certain amount of skill to get a correctly exposed image.

Scene modes

Most digital cameras have scene modes, which contain settings that are applied automatically for certain shooting conditions. This removes the need to select settings such as aperture or shutter speed for capturing specific shots such as portraits. Scene modes can be selected from either a camera's menus or a dial on the camera body.

Some of the most common scene modes are:

- Sport mode. This enables you to capture fast-moving action, such as sporting events. Sport mode uses a fast shutter speed to freeze the action, rather than it being blurry

- Portrait mode. This enables you to capture portraits against a softened background. Portrait mode creates a shallow depth of field so that the background of the image is thrown out of focus, thus emphasising the main subject

- Landscape mode. This enables you to capture landscapes in vivid colors. In landscape mode the focus is set to infinity

- Close-up mode. This enables you to capture images at very short distances. The camera focuses continually until the focus is locked and the final distance at which the image is in focus depends on the focal length of the lens used

- Fireworks mode. This uses a slow shutter speed to capture the effect of fireworks at night. A tripod is essential for this type of mode as it will result in a blurred image otherwise

- Backlight mode. This can be used where the main subject is in front of a brightly lit area. In this mode, the flash will fire automatically to illuminate the main subject and so equalize its lighting with the brighter background

- Snow mode. This can be used when capturing images in very bright conditions. In this mode, the lighting of the brightly lit areas will be exposed accurately without altering the exposure of any other objects in the image

When using scene modes, check the settings that the camera selects for each mode. You can then try using these settings for other similar shots, without having to use the scene mode.

Camera settings

In common with film cameras, the digital variety have a number of settings that can be used to get the best images in different situations. These include:

- ISO equivalents. In film cameras the ISO number refers to how sensitive a film is to light. The lower the ISO number the less sensitive it is, with 100 or 200 being standard for normal outdoor light. Digital cameras have an ISO equivalent figure, usually ranging between 100-1600. Unlike film, this can be changed from shot to shot and it is useful if you are capturing images in different lighting conditions

- White balance. White balance refers to the fact that cameras and the human eye see light differently. For instance, artificial lighting can cause problems and so this needs to be adjusted with the white balance settings. These can be set for daylight, incandescent, fluorescent, cloudy, shade and flash

For more information, and examples, about white balance and metering options, see Chapter Four.

- Metering. Most digital cameras have settings for measuring the amount of light in an image. These are matrix (the whole image), spot (the center of the image), or center-weighted (with the main emphasis on the center)

- Number of shots. More and more cameras now have a function for capturing multiple, consecutive images. This setting will determine how many shots are captured consecutively while the shutter release button is held down

- Sharpening. This determines the amount of sharpening that is applied to an image when it is captured. This can make the image appear more clearly defined

- Noise reduction. Noise is a consequence of digital photography where random, brightly lit pixels cause a grainy and speckled effect. This most commonly occurs when a slow shutter speed has been used, or in dimly lit conditions. There are settings that can be used to reduce the amount of noise that is in an image and it is usually a case of selecting noise reduction on or off. By default, noise reduction is usually off

Camera resolution

Although the topic of resolution was touched on in Chapter One it is a subject that can always benefit from a little revision, particularly when you are thinking about buying a digital camera.

Some digital cameras have several resolution settings, including one for capturing exactly what is seen through the viewfinder. This results in a high resolution but also large files.

The camera resolution is the number of pixels that a camera is capable of capturing on the image sensor. The headline figure quoted by camera manufacturers will be as a total (3 million) or as the pixel dimensions (1280 x 960). Most cameras have at least two settings, so you can have a low resolution (640 x 480) if you only want to display an image on a computer monitor or email it to a friend, or a higher resolution (1280 x 960) for printing images. The higher the overall pixel count a camera has, the greater the number of resolution settings that will be available.

Camera compression

In order to reduce file size, digital cameras can compress images by discarding unnecessary or redundant pixels. This creates smaller files and also results in images with a lower resolution.

If you are buying a camera make sure that you can capture images at a setting of 640 x 480. This is because if you are using images on the Web then you will want them to be reasonably small in size.

Since all digital cameras deal with compression differently it is not possible to give a definitive guide to how this will affect separate systems. One way to judge the compression of comparable cameras is to see how many images they can store on the same memory card at the maximum compression setting. If one model can store more images it means that it creates smaller file sizes but the resolution is not as high.

Resolution, compression and file size

How you use the resolution and compression settings on your camera will determine not only the quality of your images but also the size of the files that you create. For instance, on low compression and high resolution an image could take up 1.5Mb, while on high compression and low resolution the same image may only be 500Kb, or less. Before you start taking pictures it is worth determining what the final image is going to be used for so that you can set your resolution and compression accordingly.

When digital cameras capture images, some of the information in the file relates to details about the picture such as the type of camera used and data relating to the file format.

Start-up time and time lag

Because digital cameras are complicated instruments there are inevitably some drawbacks caused by the technology involved. In general, these most commonly involve timing issues: since there are a lot of electronic actions and calculations involved in taking even a single digital image, it inevitably takes longer than it would using a film camera. The three main areas to be aware of are start-up times, time lag of individual shots and time lag between when one shot is taken and when the camera is ready for the next shot.

Start-up times

Nothing can be more frustrating for a photographer than seeing the perfect shot only for their camera to take several seconds to ready itself once it has been turned on. This is particularly applicable to compact digital cameras and it can cause real problems if you are photographing objects that are not static. One option is to keep the camera on constantly but this can drain the battery quite quickly. Most cameras have a Sleep mode so that they partially shut down if they have not been used for a specified period of time, but even then they take a few seconds to wake up again. Different cameras have varying start-up times but all compacts will take a few seconds to get all of their internal circuitry ready and working.

Shot time lag

Digital cameras are notorious for the length of time between when the shutter release is pressed and when the image is captured. This is because the camera has to perform a certain number of digital tasks before the image is captured. This is now usually only fractions of a second, but it can make all the difference if you are photographing moving objects or even taking portraits. Always experiment with your camera to work out the shot time lag and then try and compensate for this when you are capturing images that require split-second accuracy.

Shot recycling time lag

Another problem of time lag can occur between shots: sometimes a camera will lock and not allow you to take another shot while it is processing the previous one. This is a particular problem at a camera's highest resolution setting and again it is worthwhile experimenting to see the length of the recycling time for an image.

LCD panel

A large number of digital cameras come fitted with LCD panels and this is an innovation which has considerable advantages, but also a few drawbacks. However, the advantages greatly outweigh the disadvantages and this will undoubtedly become a standard feature on all digital cameras in the near future.

Once the novelty of using an LCD panel has worn off (and this may be when you have drained your first set of batteries) create your own guidelines for its use. Try not to use it to review every image that you take, but run through a whole set when you have finished. If possible, program the relevant settings into your camera through your computer before you start shooting. This way you will not have to keep changing the settings via the LCD panel.

The LCD panel is a small screen at the back of the camera that can be used to review images that have been captured in the camera and change the settings within the camera. This can be very useful for the following reasons:

- You can review and edit the images in the camera and delete any you do not want, thus freeing up more memory. This is useful if your memory card is full and there are still some shots that you want to capture

- Through dialog menus you can change the resolution, compression, exposure and lighting settings and also add basic effects to your images such as borders. In many ways this replaces the setting controls on a conventional camera

The drawbacks to an LCD panel are:

- It uses up a lot of battery power. If you use an LCD panel to review or edit images for much more than 20–30 minutes then you'll soon find that your batteries are running down. This is especially the case if you also use the LCD panel as an additional viewfinder

To save batteries, use an AC adapter whenever possible when reviewing and editing your images.

- It is another piece of delicate technology that has the potential to malfunction

- There is the potential for making mistakes, such as deleting all of your images by accident

- It can be hard to view images in direct sunlight

An additional viewfinder

As well as its reviewing and programming functions, an LCD panel can be used as an additional viewfinder to frame and capture images. If you turn the LCD panel on when you are in picture capture mode you will see a moving image appear in the panel, a bit like an image from a video camera. This is the same (or nearly the same) view as you will see through the standard viewfinder and you can frame your image this way. This can be useful if you want to take close-up pictures of items in inaccessible places.

If the LCD panel is being used as a viewfinder it can sometimes be difficult to see the image if bright light is falling on the panel. In some cases you may have to move the camera slightly to see the image clearly, but this may then alter the framing of your shot.

Although using the LCD panel can be useful for specific instances it should not be used as the standard method of framing your images. This is because:

- Using the LCD panel in this way can use up the batteries at an even more alarming rate than reviewing pictures does (imagine running a video camera with four AA batteries)

- Since the camera is being held away from the face it can be harder to hold it still and the resultant image could be blurry or out of focus. If you practise this technique then you should be able to get to a point when you can usually capture sharp images using the LCD panel

However, the LCD panel when used as a viewfinder displays a more accurate image of what will be captured by the camera than the camera viewfinder does.

Some digital cameras have an LCD panel that can be flipped out and twisted away from the main body of the camera, enabling shots in awkward positions

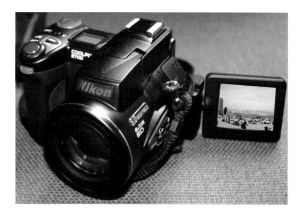

Lenses

When you are investigating the lens of a digital camera, make sure that it is made out of optical quality glass.

Fixed

As with a large number of compact film cameras, a lot of digital cameras are manufactured with a fixed focal length. This means that the distance from the center of the lens to the film, or image sensor, is fixed at a certain setting. For a lot of point-and-press cameras this is usually 35mm, which is a good multi-purpose setting for most circumstances.

With digital cameras the actual focal length is different from the figure that is usually quoted on the box of the camera. This is because, as with aperture and shutter speed terminology, the digital camera companies thought that it was wise to stick to what people already knew and so they provide an equivalent focal length figure. So a digital camera that has a 35mm equivalent may only have an actual focal length of approximately 5mm. This is to do with the way the technology of the lens and the image sensor interact. As long as you know the equivalent focal length figure you do not need to know how it is arrived at.

Zoom lenses

If you are buying a camera with a zoom lens, make sure that it is an optical zoom rather than a digital one. An optical zoom is the genuine article, while a digital zoom only enlarges the object in the center of the picture by making the pixels bigger. This is an operation that you could perform equally well with your image editing software.

As digital cameras are getting more sophisticated so zoom lenses are becoming more common on even the entry-level models. This enables you to view an image with a varying focal length, generally in a range of 35–350mm on some models (see below). This allows you to view subjects at a magnified level without having to move too close to them. In some instances, the zoom lens function will sacrifice the picture quality a little, but it is a useful option to have.

Flash

Most flashes on digital cameras in the low-to-middle end of the market are not particularly powerful and only useful for basic flash work. If you rely heavily on a flash then you will have to splash out on a higher specification model.

Digital flashes often come with a number of settings:

- Auto. The most straightforward flash setting on a digital camera is Auto. This means the camera decides whether there is enough light for the shot and activates the flash if conditions are too dark

- Off. This turns off the flash completely

- On. This fires the flash with every shot, regardless of the lighting conditions

- Red-eye reduction. This fires the flash before the picture is taken and again when it is captured

Although image sensors need good levels of light to operate well, some cameras take surprisingly good pictures indoors without a flash, particularly in a well-lit room. Keep an eye out for the artificial light affecting the naturalness of the colors in your image though.

The use of flash can produce considerably different results in an image, even in normal lighting conditions

Red-eye reduction with flashes can be a bit of a hit and miss affair. It can give the eyes a more natural look but it does not always work and it can be disconcerting for the person being photographed.

Batteries

When digital cameras first appeared on the scene, battery manufacturers must have started to rub their hands in gleeful anticipation. Digital cameras use a lot of battery power. And if you are using the LCD panel you can almost see the power draining away before your eyes.

Battery usage has traditionally been a big problem with digital cameras. However, manufacturers have been addressing the problem and the situation is improving with most models.

Battery usage

Some digital cameras use alkaline batteries while others increasingly use lithium batteries, which last two or three times longer than standard alkaline batteries. Check when you are buying a camera what types of batteries it takes and how many images (roughly) they will be able to capture per set. There are also a few general guidelines that can be applied:

- Take the batteries out of the camera if it is inactive for long periods of time

- Replace sets of batteries in their entirety. Do not just replace two batteries out of a set of four

Look for cameras that have a display that tells you how much life there is left in your batteries. This can save you from being caught out if your batteries pack up without warning.

- Do not mix alkaline batteries with other types

Rechargeable batteries

Considering how quickly standard alkaline batteries can be used up by a digital camera, it is reasonable to say that rechargeable batteries are a necessity rather than an optional extra. These usually come in the form of NiCad or NiMH batteries. The best form of battery is a lithium one that can be recharged and gives impressive duration in most cases.

Some newer digital cameras use rechargeable lithium batteries as their power supply. These are an excellent option as they last longer than either the NiCad or NiMH varieties.

Look for cameras that use rechargeable lithium batteries but try and ensure that they are fully drained before you recharge them

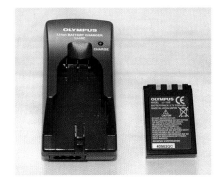

Additional features

TV playback

One useful feature on a digital camera is the ability to show images via a television screen. This way you can set up your own slide shows for friends and relatives without having to worry about projectors or screens.

If your camera supports this function, you can set up a television playback display by selecting the relevant mode on your LCD panel and then plugging a video cable into the camera and your television. Then, when you press the relevant Start button on the camera, your images will appear on the screen.

Image information

Via the LCD panel it is also possible to view information about individual images, in much the same way as you would with files on a computer. The type of information that is available includes:

Different cameras have different additional features. It is best to decide first which ones you want and then try to find a camera that satisfies these needs.

- File name. The individual name of each image

- File size and resolution settings. The overall size of an image and the resolution setting at which it was captured

- Date and time of capture. This can also be displayed on the final image, if desired

- Aperture setting. Displays the equivalent f-stop number for each image

- Shutter speed. Displays the equivalent shutter speed

- Flash details. Displays the type of flash that was used

- Exposure settings. The setting at which the exposure was measured for the image i.e. the method for measuring the amount of available light

- White balance settings. The setting for the current lighting conditions. This can be adjusted for external capture or under artificial lighting conditions

Digital images contain information that is used within the camera itself and also in image-editing software. This information relates to areas such as file formats and the type of camera used when capturing an image. Although the user never sees this information, it is very important for the processing of digital images.

Camera software

When you are assessing digital cameras it is important to keep an eye on the software with which they are supplied. This usually consists of two types: system software and imaging software.

Camera to computer communication

The software linking the camera to the computer is an integral part of the camera itself – without it you will not be able to transfer your images to a computer. It will almost certainly come on a CD and the manual will include full installation instructions. What the camera software does is allow the camera and the computer to communicate with each other. Once this channel of communication is established you will be able to do several things:

When you link up your camera and computer, error messages can appear for a variety of reasons: the camera is not connected properly; the camera is not turned on; you have more than one type of the system software running

- Download your images onto your computer

- Catalog and edit your chosen images

- Change the settings on your camera

Windows XP and Mac OS X

Both of the latest Microsoft and Apple operating systems are designed with digital camera users in mind. Both of them have software for the most commonly used digital cameras already preinstalled. This means that when you connect a camera, the operating system will recognize it and supply the appropriate software, known as a driver. If the operating system does not recognize the camera then you will be given the option of loading the camera software manually from a disc, usually a CD:

Image editing software

The minimum you should be looking for in terms of software is a medium-range editing program such as Adobe Photoshop Elements or Ulead Photo Express. In some cases you may also need additional utilities for tasks such as image cataloging and Web authoring. Shop around to see what is on offer in different outlets. It may be possible to negotiate different deals.

It is an unfortunate fact that some retailers who sell digital cameras do not know enough about them. If you feel you have not had satisfactory service, then look elsewhere.

Digital camera checklist

To summarize, bear in mind the following points when you are considering which digital camera to buy:

- Decide what you want it for: use on the Web, hard-copy prints or both

- The size of images is determined by the number of pixels that a digital camera can capture. Most cameras on the market today can capture a minimum of 3 million pixels. This is also known as the megapixel value of a camera. If images are going to be printed, then a camera with a higher pixel count is best

- Look for the "effective" pixel count of a digital camera, not just the headline figure. The effective figure is less than the headline one because cameras use a proportion of the pixel count for calibration and processing images

- Be aware of the types of memory cards: CompactFlash and SmartMedia are the two most common but all types work effectively for capturing and downloading images

- Decide how you want to download your pictures to your computer. This can be done by cables or card readers. With operating systems such as Windows XP and Mac OS X and a USB cable connection, images can be downloaded quickly with no additional software

- Battery life is a vital issue for digital cameras. Check the battery life of different models. Make sure you use rechargeable batteries and a battery charger

- Look for a camera with a good quality optical glass lens

- Look for a camera with an optical zoom lens rather than a digital. An optical zoom is an actual zoom; a digital one just crops the image in the viewfinder and then adds more pixels by guesswork

Digital camera techniques

A lot of techniques for capturing digital images are similar to those in traditional film photography. This chapter looks at some of the common techniques for capturing digital images and explains how to get the best out of your camera in different situations.

Covers

Chapter Four

Focusing

Anyone who has ever fiddled with the focus controls on a manual focus camera will appreciate the advances that have been made in this area in recent years and the options that are now available. Manual focusing is available on the more sophisticated models of digital camera, but the standard ones have two main settings: fixed focus or autofocus.

Fixed focus

As the name suggests this is a focusing system that is fixed in place and cannot be altered. Everything within a certain range will be in focus and anything outside the range will not. The settings are generally from approximately 1 meter to infinity. This is fine if you are taking general or landscape shots but not so good if you want to do a lot of close-up work.

Autofocus

This is an increasingly popular system whereby the camera focuses automatically on the subject in the viewfinder. It does this by using light beams to measure the distance between the lens and the subject and then selecting the focus accordingly.

In order for autofocus to work the user has to give the camera a helping hand. This is done by half depressing the shutter button and then waiting until the camera focuses on the subject. Once it has done this a light will appear or the camera will beep. You then proceed by fully depressing the shutter button. One of the drawbacks with autofocus is that it can have problems in low level lighting, when there is very little contrast within the image on which it is trying to focus.

Special settings

Some cameras offer special settings such as Infinity or Close-up for occasions when you may want to capture particular types of images. This sets the camera's focus to certain levels (for instance, the Close-up setting may be in the range of 0.25–0.5 meters) and also sets the appropriate levels of flash. Although this can be useful for certain types of shots it can be a bit limiting too: if your subject is just out of the range of focus then you would have to reposition yourself since the focus cannot be altered from the set levels. The Infinity setting will probably be used less frequently than the Close-up one.

With an autofocus camera it is possible to lock the focus on a certain point and then reposition the camera to capture an image. This is done by framing the subject, activating the autofocus, and then, with the shutter button still half depressed, repositioning the camera before you take the shot.

If you are worried that low level lighting will cause problems with autofocusing, take some test shots first and then preview the results. If this is going to be a problem, try to introduce an additional light source into the shot.

Through the viewfinder

A viewfinder on a digital camera is very similar to one on a standard point-and-press camera. This means that, since it is positioned away from the lens of the camera, it views the subject from a slightly different angle. This can cause a problem known as parallax, which means that everything you see through the viewfinder will not be captured through the lens. To overcome this potential hazard, there are sometimes marks around the edges of the frame which indicate the area that is going to be seen by the lens. It is important to pay attention to these marks or else it could result in parts of your image being cut off. One way to get around this problem is to use the LCD panel to frame your images, since this is the same view as the one the lens sees.

Some mid-range and professional digital cameras now capture images exactly as they are seen through the viewfinder.

The closer you get to a subject, the greater the danger of having a part of the picture cut off. Tops of heads are particularly at risk from this problem.

Parallax can cause a subject to appear off-center

Exposure

Although a lot of digital cameras automatically set the exposure (the combination of shutter speed and aperture settings that determines the amount of light falling on the image sensor), there are usually options to determine how this calculation is arrived at. With the increasing development of cameras currently on the market, it is becoming more common for all ranges of cameras to have at least some type of manual exposure settings.

Some cameras allow for exposure compensation. This means the user can adjust the exposure by the equivalent of +5 or -5 in f-stops. This is particularly useful if your images are under- or overexposed. If your pictures are too dark then increase the number and if they are too bright, decrease it. See page 60 for details.

Spot metering

This is where the camera takes a light reading from the subject in the center of the lens and makes the exposure setting accordingly. This can be useful if you are capturing an image against a very light background. Since the exposure is being taken from the center of the frame it should be correctly exposed. However, if it is a dark center and a balanced background then the image can appear too dark, as in the bottom image on the facing page.

Center-weighted metering

This is similar to spot metering in that it takes the main light reading from the subject in the center of the image. However, it also measures the light around the edges of the image, although it still gives prominence to the center.

When you first get a digital camera, experiment with the exposure settings. You will be able to see the results immediately and get to know the effects it produces. This will make you more confident when you are taking shots that really matter.

Multi-pattern metering

This method arrives at an exposure reading by measuring the amount of light in the whole image, not just the center. This is similar to putting a grid over the image and taking light readings from each individual cell. This is probably the best setting for general use and produces an even exposure, as in the top image on the facing page. This method is also called matrix metering.

Experimenting with settings

The majority of digital cameras have default exposure settings which usually involve a multi-pattern reading. It is perfectly feasible to take all of your digital photographs without ever changing the exposure settings, and you will probably achieve good results. However, it is a good idea to experiment with the various exposure settings on your camera. This will give you more options when you are capturing images and it may come in useful if you are ever in a situation that requires a particular exposure setting because of the lighting conditions.

Exposure compensation

When measuring the amount of light in an image for exposure purposes, even the most sophisticated cameras can get it wrong sometimes. This can occur if there are items that confuse the metering process and so expose the final image incorrectly. For instance, if there are very light and very dark areas in an image, the exposure may be calculated for the dark area, so the light area will be over-exposed. There are three ways to try and compensate for over- or under-exposure:

- Use a different method of metering. If the spot metering method is being used this may cause the problem with the exposure. Use the matrix method instead to get a light reading from the whole image to see if this makes a difference

- Use exposure lock. Most digital cameras have an option for locking the exposure. To do this you take the exposure from one specific part of the image, hold down the exposure lock button and then recompose the image for the one that you want. When the image is captured it will use the exposure setting from the original reading

- Use EV exposure compensation. EV stand for Exposure Value and it is a technique for changing the exposure of an image without altering any other settings. It works by letting more, or less, light onto the image sensor than would have normally been allowed at the current aperture and shutter speed settings. This has the effect of making an image lighter or darker. EV settings usually go up in incremental values, to +/- 2, 3 or 5, depending on the type of camera. To make an under-exposed image lighter, set a positive EV value; to make an over-exposed image darker, set a negative EV value

In the examples on the opposite page the top image was taken without any EV settings applied and the dark foreground has caused the background to be over-exposed. In the bottom image a value of -2 was applied to compensate for the over-exposure and so improve the overall image.

Using light

Using natural light

Digital images can be captured under any lighting conditions, but the best option is to use natural light, if possible. However, there are some points to bear in mind when using natural light:

- Look at where the light source (usually the sun) is coming from. See if your main subject is in shadow and, if so, consider whether it is possible to reposition yourself so that the subject is more evenly lit

- See if the light source is going to change. This can occur if the sun is behind a cloud or a building. Sometimes it is worth waiting a few minutes until it moves position

- The best type of light for a photographer occurs first thing in the morning and in the evening. The angle of the sun produces a softer light that gives a richer color to images. The image below was taken in the evening and the one on the facing page was taken first thing in the morning. This gives a much better color and texture than would be seen if the images had been captured under the harsher midday sun

Shooting in low light

If you are faced with capturing a digital image under poor lighting conditions there are a number of options:

- Come back when the light has improved

- Take the shot and hope that you can edit the image sufficiently with your image editing software

- Use flash if the subject is within range

- Try to use an additional light source

- Increase the ISO equivalent setting on the camera to 400, 800 or even 1600

If you are a perfectionist who always wants to have the optimum lighting conditions then you could be in for a long wait on occasions. Some photographers have been known to wait for weeks to get the perfect light. At least with image editing software there is now an alternative if you do not have time on your hands.

Adjusting lighting problems

There can be occasions when there is too much light. One instance of this is if there is an area of light that is brighter than the rest of the image. The result is that a hotspot appears in the final image, i.e. an area where the amount of light has created a bright, white blur. It is possible to try and rectify this by adjusting the exposure but the three most effective remedies are:

- Reposition yourself

- Wait until the sun moves position slightly so that the glare is not so pronounced, or has disappeared completely

- Use something to shade the offending items out of the image. This could be as simple as holding up your hand to cover the glare from reflected sunlight

If you are experimenting with taking shots into the sun, do not look directly at the sun through the viewfinder as this could cause damage to your eyes.

However, there are times when it is advantageous to deliberately break the rules and include an area of bright light in an image. The image on the facing page was taken directly into the sun, giving a dramatic effect to the picture. With this type of shot you have to be careful that the main subject does not become under-exposed because of the amount of bright light elsewhere.

As digital cameras are becoming more advanced, they are becoming much better at dealing with difficult lighting conditions. This is particularly true of mid-range and professional models, some of which are approaching the standards of their film counterparts.

Fill-in flash

If you are capturing images on a bright sunny day you may think you have the ideal shooting conditions. However, there is one stumbling block that can occur under these circumstances and this is called backlighting. This happens when you are capturing an image, usually of people, when the subjects have their backs to the sun, resulting in their faces and fronts being in shadow. The subsequent image can be unsatisfactory, as it appears to be a bright sunny day in the background and yet the subject looks dull and uninspiring.

There are a couple of ways to deal with backlighting:

- Ask the subject to move so that the light source is facing them

- Use fill-in flash to make your subject as bright as the background

The option of fill-in flash is probably the most effective for rectifying backlighting problems. One point to remember is that you may have to turn the flash on, rather than relying on the camera to use it automatically: if it is a bright day it may calculate that a flash is not required.

When using fill-in flash, make sure you are reasonably close to your subject. Otherwise the flash will not be powerful enough to brighten up the areas of shadow.

Thinking in black and white

Black and white images can produce some of the most evocative pictures. When capturing images it is worth bearing this in mind and trying to look at scenes to see if they would produce good black and white images. The key to this is good contrast between the lightest and darkest parts of the image: if there is not enough contrast then the image may look rather flat.

It is possible to remove the color from digital images in image editing software and some cameras also have a facility for capturing black and white images directly. However, it is also possible to capture color images that are virtually in black and white, depending on the lighting conditions. The image on the facing page is actually a color one but has the effect of appearing black and white, but with a slightly added depth of color.

Film speed equivalent

As mentioned in Chapter Three, with film cameras the film speed (also known as the ISO rating) applies to the film's sensitivity to light. A standard film speed is 100 or 200 for brightly lit conditions. This can go up to 800 or 1600 for dimly lit shots.

Although digital cameras do not use film, they still have the same film speed ratings, expressed as ISO equivalent speeds. This refers to how much light is captured by the image sensor for a particular shot. If the ISO equivalent rating is 100 or 200 it means that the image sensor is less sensitive to light and so can capture images in bright conditions. However, a higher ISO equivalent rating means that the image sensor is more sensitive to light and so can capture images in more dimly lit conditions. Here are some points to note about ISO equivalent ratings:

- In general leave your camera on the default ISO equivalent rating which will probably be 100 or 200. This will deal with most normal daylight situations

- ISO equivalent ratings can be changed from shot to shot on a digital camera

- The higher the ISO equivalent rating, the more "noise" will be introduced into an image. This is randomly colored pixels that occur because there is not sufficient light to capture all of an image's color information correctly

- High ISO equivalent ratings, such as 800 or 1600, can be used to capture images in dimly lit situations, such as indoors or even at night. The image on the facing page was captured with an ISO equivalent rating of 1600. However, even then it also required a slow shutter speed to allow enough light to be captured by the image sensor. For this type of shot it is essential to use a tripod

- Experiment with different ISO equivalent ratings to see how they affect the final images, particularly for low-level lighting situations

White balance

Unfortunately, since cameras are not as clever as the human eye, they sometimes have trouble distinguishing between different types of light. This is because different light sources have what is known as different "color temperatures". This means that the color reflected from an object is different depending on the type of source light. For instance, the color reflected from a piece of white paper in direct sunlight will be different from that reflected from a piece of white paper under fluorescent lighting. Since the human eye is so sophisticated, it can compensate for these changes so that the original object always looks the same: i.e. the piece of paper always looks white. However, cameras cannot do this so have to compensate with white balance to try and ensure that objects always appear the correct color, regardless of the light source.

Flash is one area that is sometimes overlooked in terms of white balance but this can be just as important as other lighting conditions.

Digital cameras have a default setting for measuring the white balance in an image. This works by assessing the type of light in the image and then adjusting the white balance accordingly. However, this does not always work perfectly (particularly under artificial lighting) so manual adjustments can be made for different lighting conditions. These take into account different external and internal lighting conditions and usually cover: auto, shade, sunlight, cloudy, fluorescent, incandescent and flash. Adjusting the white balance settings is particularly useful in artificial lighting conditions and is worth experimenting with.

In most cases it is also possible to preset the white balance for certain shooting conditions. This involves selecting the appropriate white balance option from the camera's white balance menu. To do this, place a piece of white or gray card at the point where you are going to capture the image. From the white balance menu select the option for manually recording the white balance and capture the image with the card in the center. The camera will then calculate the required white balance for these lighting conditions and adjust the lighting in the final image accordingly.

Whenever you change the white balance setting for a particular scene, make sure you reset it when you are capturing images under different lighting conditions.

In the examples on the opposite page the top image was captured using the correct white balance setting (fluorescent) while the one on the bottom used an incorrect setting (sunlight), resulting in an unnatural color cast in the image.

Depth of field

The depth of field in an image is the area in front of and behind the subject that remains in focus.

Depth of field is an important consideration if you want to have a subject that is sharply in focus while the background is blurred. This can be an effective technique because it gives more prominence to the main subject in the image. If the image is captured with a larger depth of field then the main subject gets slightly lost in the background. This can be particularly distracting if the background is multi-colored or it contains numerous different items.

Depth of field can be changed by moving the subject in relation to the background. A few digital cameras currently on the market offer settings that can affect the depth of field. However, most of them do not and it is a case of experimentation and improvisation.

If you want to create an image with a blurred background and you cannot generate this through depth of field, then a similar effect can be achieved with image editing software. The main subject can be isolated from the rest of the image and then a blurring or softening effect can be added to the background.

Depth of field is altered by changing the aperture setting on a camera: the wider the aperture (e.g. f 2.8 or equivalent) then the less the depth of field, i.e. the area of the image that remains in focus is reduced (see top image on facing page). The narrower the aperture (e.g. f 22 or equivalent) the greater the depth of field, i.e. more of the image will be in focus (see bottom image on facing page). Another way to change the depth of field is to move yourself, or your subject, so that there is a greater distance between the subject and the background.

Altering the depth of field with digital cameras works best with close-up shots, when there is a reasonable distance between the subject and the background.

When you are capturing landscape shots, one consideration for depth of field is when you want to capture a foreground element and have the background features in focus. To achieve this you may have to experiment with capturing the image from different viewpoints, unless you can move any of the elements of the image. The focal lengths of a lot of digital cameras allow for a large depth of field to be captured and so it is usually reasonably easy to keep the foreground and the background in focus.

Close-up objects

Changing the depth of field is a very effective technique for portraits and close-up objects:

Depth of field is also affected by the type of lens being used. A telephoto lens has a much lower depth of field (less of the area will be in focus) while a standard lens creates a greater depth of field.

If you achieve a depth of field effect that you particularly like, check the exposure at which the image was captured (this can usually be done through the image information control on the LCD menu). This may help you to recreate the effect in the future.

Capturing digital images

This chapter looks at the best ways to capture digital images and how to get the best out of different situations. It also covers composition matters to take your photography to the next level.

Covers

Landmarks

Capturing images of stunning scenery and notable landmarks is a popular area of photography, particularly for the holidaymaker or the travel photographer. With a digital camera the process is simplified because you do not have to carry a bulky camera and numerous rolls of film with you. Just stock up on memory cards and batteries and set off into the wide blue yonder. However, if you feel you may run out of space on your memory cards, be ruthless and delete any sub-standard images.

Landmarks

When capturing landmarks, whether they are international, national or local, the first thing to remember is that they have probably been photographed thousands of times before. We have all seen picture-postcard shots of the Statue of Liberty or the Eiffel Tower. If you are capturing an image of a famous building or statue, bear in mind what has gone before and try to be a little bit different.

One way this type of image can be given an extra dimension is to get away from the main tourist vantage points. The image on the facing page was captured by walking away from the crowds to a nearby park. This has the advantage of creating a more interesting foreground and also hiding the tourist buses behind the trees.

Another way to liven up a landmark shot is to have another object of interest in the picture. Sometimes this may depend on luck – if a hot air balloon floats past as you are capturing the Leaning Tower of Pisa – or else you can be creative and add your own props. This could be in the form of an object or a person. Use your imagination but do not do anything that may harm the object you are capturing. You could include items such as:

- A colorful piece of material placed in an image – such as a red handkerchief placed in the hand of a statue

- Items such as flowers or flags

- Other people – interesting-looking people can make great props next to landmarks

If you are traveling abroad with your digital camera and you are using rechargeable batteries, make sure you know the voltage of the power supply in the country you are visiting. Find out if you need an adapter and take one with you rather than relying on getting one when you arrive.

If you are going to be away from home and intend capturing a lot of images, consider the security of your full memory cards. Either send them back home or store them as securely as you would your passport.

When capturing images of landmarks, try and get up early and visit first thing in the morning. This will ensure a much better quality of light and you will also be ahead of the tour parties.

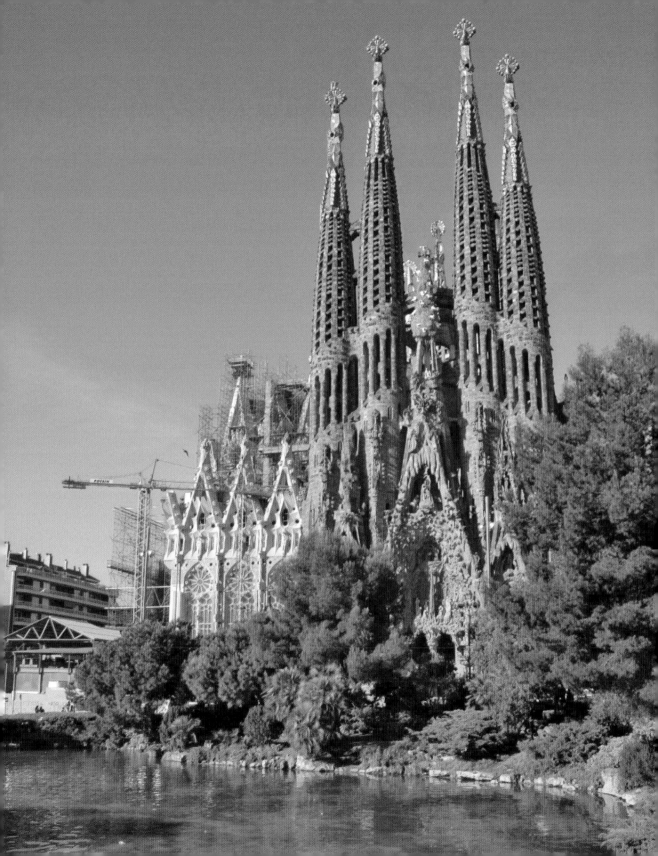

Landscapes

If you are there, a glistening mountain range or a stunning sunset can be a wonderful sight. If this is then captured on a digital camera it can result in an excellent image. However, if you are displaying your holiday snaps, one shot of a beautiful sunset can be dramatic but a dozen can become tedious.

It is a fact of life that we all like to see images with people in them, even if they are people we do not know. They add perspective and meaning to an image, particularly if it involves another country or another culture.

The best lighting conditions for photography are usually first thing in the morning and early evening. Always consider the quantity and quality of light when you are capturing images.

If you are taking landscape shots try to include an object, animal or person that can act as the focus of attention in the image. This could take a number of forms:

- A climber on a mountain ridge. In instances like this, make sure that the person or object is of a sufficient size in the image to be seen properly

- A boat in front of an evening sunset. Try getting the boat silhouetted by the setting sun

- A fisherman on an otherwise deserted lake

- A child playing with a ball on a beach

If you are impatient you may get a picture but it will not be the best possible one. Be prepared to wait until a suitable object appears in your image or your subject does something out of the ordinary.

- A car driving along a dirt track, with a plume of dust rising behind it

If you make the object the center of attention in your image this will give it added impact and also serve to emphasize the natural beauty of the scenery. However, this does not mean that you have to position your object in the actual center of the image. An off-center object frequently improves the composition of an image and this is known as the rule of thirds (see page 86).

However, there are times when the lack of an object of focus can add emphasis to an image. In the image on the facing page the lack of people on this normally busy staircase creates added impact and also gives a better perspective to the image.

Buildings

Buildings have always been a popular choice of subject matter for photographers. If you want to go for an artistic shot then, through the use of different angles and viewpoints, buildings can be given an unusual or interesting appearance. On the other hand, if you just want a straight shot of a building (perhaps for an advertisement if you are selling a house) then this can be created quickly and easily with a digital camera.

One of the most important factors when capturing the exteriors of buildings is to use the natural symmetry of the building. This can create an interesting geometrical shape, as in the image below, or it can be used to create a sense of perspective by using the natural lines in an image to show them converging at a single point. This can best be done by shooting upwards from directly below a building, thus making it appear more imposing.

Images of the interiors of buildings can also be effective. One of the major considerations here is the amount of available light, as the use of flash may not be possible. If this is the case, use a high ISO equivalent rating, such as 1600, and a slow shutter speed. The image on the facing page was captured in this way, using a tripod.

If you cannot stand far enough back to capture the whole of a building you will have to use a wide angle lens. If you have a fixed lens then you will have no choice but to try and take the shot from a different angle.

Interior shots of a house can be used to catalog items for insurance purposes or to assess the layout for redecorating purposes. It is even possible to use image editing software to experiment with how different colors would look in the interior.

When capturing interior shots, be conscious of different light sources in your image. One may be natural light, another fluorescent light and a third tungsten light. This could affect the color balance of the final image.

People

Capturing images of people and particularly children is one of the most popular uses for any kind of photography. However, a digital camera and its ability to review images immediately offers an added dimension – both the photographer and the subjects can see the images immediately and make any necessary adjustments accordingly.

Group shots

Even if you are happy with a group shot once you have viewed it on the LCD panel, take a couple more to be on the safe side. It is not always possible to see all of the detail and there may be a blemish that is only visible when the image is viewed on a computer monitor.

The greatest problem in capturing groups of people is that at least one person is always blinking or looking in the wrong direction when the picture is taken. With traditional film this does not become evident until the developing process has been completed. However, with a digital camera this can be spotted immediately, via the LCD panel, and another shot taken.

When you are photographing a group of people take a few shots and let everyone see the images on the LCD panel. They will then know how they look in the image and make any adjustments that they see fit.

Rather than having a static group of people staring at the camera it is always a good idea to arrange people in a variety of positions (standing, sitting, kneeling and even lying down) or ask them to position themselves around an additional object, such as a bench or a car. This will create an image that is more original – plus it will be more fun preparing the shot.

You can include yourself in a group shot if your camera has a self-timer option. However, these shots frequently look a bit unnatural, as everyone is staring at the camera wondering when the shutter is going to go off. Take two or three shots like this, so that everyone can get used to the method.

Also, a good technique for group shots is to ask everyone to close their eyes and look downwards. Then, on your signal, they look up and open their eyes. If you capture the shot at this point then you will get better expressions than the usual fixed grins.

Candid shots

One of the most effective uses of people in images is to capture candid shots. This can add context to an image and it is also useful as the subjects appear more natural. Candid shots can be used to add interest to a scenic shot, as in the top image on the facing page, or they can capture specific actions, as in the bottom image on the facing page.

Children

Portraits

Children can be both a joy and a menace to capture with a digital camera. They love the immediacy of seeing themselves on a mini screen seconds after the image is taken. This can result in them wanting to become more involved in the photographic process, which can have its advantages and its disadvantages.

Children love digital cameras because they can see the images immediately. However, be careful about handing a camera over into little hands and make sure children always use the neck strap.

The most common images of children, and the ones most likely to adorn the mantelpieces of parents and grandparents, are the face-on portraits with the child looking directly at the camera. With a little planning these can be made to look even more appealing:

- Take the image against a neutral background

- Move down to their level. This will make them feel more comfortable and also result in an image in which they are not staring up at the camera. Relaxed-looking pictures of children are frequently the most effective

Activities

Another popular way to capture images of children is to do so when they are engaged in a particular activity (see images on facing page). This shows them in their natural environment, when their attention is diverted away from the camera. Some areas to consider for this are:

- Playgrounds

- Zoos or animal parks

- Sporting events, such as school sports day

Children's natural propensity for perpetual motion can sometimes cause a few problems when you are trying to capture an image with them performing a certain activity. If you are trying to catch an active child running or throwing a ball the result can be blurry and out of focus. To avoid this, try capturing these images under good lighting conditions so the shutter speed is as fast as possible and there will be less time for the image to blur.

If you are taking pictures of children in public amenities, such as swimming pools, check first to make sure this is permitted and obtain the necessary permission if required.

Children do not always do exactly what you expect when you are photographing them. Be patient and be prepared to take a lot of shots to get the one you want.

Rule of thirds

As mentioned earlier it can improve an image to have the main subject out of the center of the image. This can give it a more natural appearance and make it look less posed. However, it is not just a case of positioning the subject anywhere out of the center of the image, which could result in an unbalanced picture. Imagine your image as a grid of 3 x 3 squares and position your subject at the intersection point of any of the grid lines or in one of the subsequent sectors (see below). This should provide you with an eye-catching and balanced composition.

This is known as the "rule of thirds" and it can be applied to give an image a completely different perspective. Always keep this in mind when you are capturing images and place the subject in different areas of the rule of thirds grid. In the two images on the facing page the composition of the pictures has been altered considerably by moving the main subject to different points in the rule of thirds grid. This can also have an impact on the exposure of the image.

Moving the horizon

A similar technique to the rule of thirds is that of moving the horizon. This is simply a case of moving the camera so that the horizon appears at different places in each shot. If you do this then you can have three shots with the horizon at the top, middle and bottom of the image. These types of shots work best when there is a straight horizon that is largely unobscured by buildings or scenery. The three images on these two pages were captured from the same point and create different viewpoints by altering the position of the horizon.

Composing with natural elements

When you are composing shots, the natural elements that are available can be incorporated into the final image. Some ways that this can be done are:

- Using natural objects to frame a subject. This is similar to putting the image in a frame once it has been captured. However, if the frame occurs naturally then this gives the image extra relevance. In the image on the facing page, the tree is used to frame the top and side of the main object. For this type of shot you may have to move around until you are in the best position to compose the image correctly

- Using the natural space in an image. Do not underestimate the value of space in an image. It can be used to emphasize the vastness of a scene and give the subject a chance to express itself. This is often referred to as "negative space" and this should be kept in mind, particularly when capturing large objects. Do not just look at the subject of an image; give some consideration to the space around it and how this will affect the composition of the image

- Using constructed objects. This can include items such as arches, poles and windows. Arches can be used to create a black silhouette around a subject or they can retain their natural color to add texture to the framed image

- Incorporating moving elements such as fountains. In the image on page 92 a fountain has been used as a foreground frame to parts of the main subject. This can involve a bit of trial and error in order to get the fountains at the correct point. A fast shutter speed can be used to try and "stop" the water and make it more clearly defined

Composing with moving elements

Downloading and organizing images

Both Windows XP and Apple's OS X have options for downloading images. This chapter shows how Windows XP downloads and organizes images and also how this is handled by iPhoto, the photo editing and organizing program that is widely used on the Mac. It also covers how to obtain images by scanning.

Covers

Chapter Six

Downloading with Windows XP

For the digital photographer Windows XP offers a considerable amount of help in downloading images and storing them on your hard drive. In most cases, cameras will be detected automatically and the images downloaded using a straightforward wizard process.

Adding digital imaging devices with XP

XP recognizes a lot of digital imaging devices automatically and displays their details as soon as they are connected. However, in some cases you may need to install the camera software manually. Once this has been done, you can start downloading images.

If XP does not recognize your camera, then it can be added as a new digital imaging device. To do this, open the Control Panel and select Printers and Other Hardware>Scanners and Cameras>Add an Imaging Device. You will then be able to select your camera and have it installed by XP. However, in order to be able to do this you will require the software that came with the camera.

1 Connect your camera to the computer and set it to the correct setting (e.g. Connect). Turn on the camera

2 In most cases XP detects the type of camera automatically

For a detailed look at the functions of XP, have a look at "Windows XP in easy steps" in the Computer Step range.

3 The required camera software (drivers) is automatically installed

4 The Scanner
and Camera
Wizard opens.
Click Next to
work through
the windows
of the Wizard,
which will guide
you through the
downloading
process

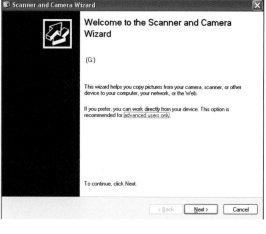

*When you are
downloading
images with
the Scanner
and Camera
Wizard you will have the choice
of placing them in one of the
existing folders on your hard drive
or creating a new one.*

5 Select the
images to be
downloaded and
click Next to
continue

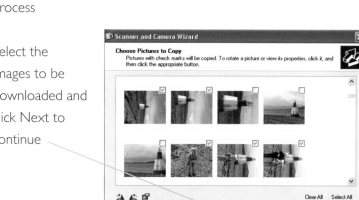

6 Click here to view the
downloaded images

Organizing and sharing with XP

XP offers tools for performing some simple organizational and sharing tasks. However, if you are going to be dealing with either of these areas in any depth then it would be advisable to use a more powerful program designed for these tasks, such as Photoshop Elements.

To organize and share images with XP

1 Access My Pictures and open a folder

2 Select View from the Menu bar and
 select an option for the way you
 want to view the images

- Filmstrip
- ● Thumbnails
- Tiles
- Icons
- List
- Details

The Files and Folder Tasks and Picture Tasks panels are available regardless of which view option has been selected. The only time they disappear is when Folders has been selected on the toolbar.

3 Select an image and select an
 option for organizing in the
 File and Folder Tasks panel

File and Folder Tasks ⦺

- ▦ Rename this file
- Move this file
- Copy this file
- Publish this file to the Web
- E-mail this file
- ✕ Delete this file

4 Select an image and select an
 option for sharing in the Picture
 Tasks panel

Picture Tasks ⦺

- View as a slide show
- Order prints online
- Print this picture
- Set as desktop background
- Copy to CD

Downloading with iPhoto

For Mac users, iPhoto is the best option for downloading images. This is a photo organizing and editing program that is bundled with all new Macs and it can also be purchased as part of the iLife suite of programs. Like XP, iPhoto can automatically detect digital cameras when they are connected to the computer and download images onto the hard drive. To do this:

iPhoto downloads all of the images held on a camera's memory card; there is no facility to select specific images before downloading.

1 Once the camera is connected iPhoto launches automatically and the camera is displayed here

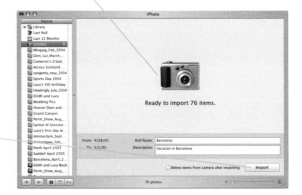

2 Click here to download the current images in the camera

Check the "Delete items from camera after importing" box if you want images to be removed from the camera's memory card once they have been downloaded by iPhoto.

3 Once the images have been downloaded, drag here to change the size at which they are displayed

Organizing with iPhoto

One of the main features in iPhoto is the organize function which can be used to create an album for images that have been downloaded. To do this:

Multiple images can be selected by dragging around them or selecting them while the Apple button is held down on the keyboard.

1. Open the main photo window

2. Click here to create a new album

3. Enter a name for the album and click Create

If you delete an image from the Photo Library it will also be deleted from any albums in which it appears. This is because each image in an album is only a reference back to the master image stored in the Photo Library.

4. Select images and drag them into an album

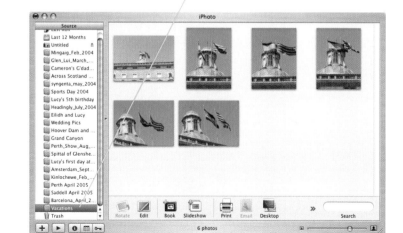

Assigning keywords

Keywords can be attached to images in iPhoto to help with organizing them and searching for them when you have several hundred, or thousand, images through which to search. To do this:

1 Select an image, or images, and select Photos>Get Info> Keywords from the Menu bar

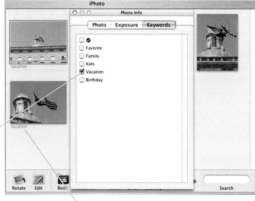

2 Select a keyword

Be consistent in your use of keywords and try to use the same system for all images that you download. Otherwise you may find that searching becomes erratic once you have thousands of images to look through.

3 The keyword is applied to the selected image or images

4 To search for images, access the Keywords dialog box and select the keyword

5 The images with the selected keyword will be displayed

Sharing with iPhoto

There are several options within iPhoto for sharing images, both as hard copy prints and online. These include

- Displaying them as a slideshow

- Creating a book of images that can be printed via an online service

- Emailing images directly from iPhoto

- Adding images to your own Web pages

- Printing images directly to an online service

The Book option in iPhoto offers a number of creative options for creating high quality photo albums that are then printed by an online service.

To share images with iPhoto

Select an image or images from the main photo window

Select one of the sharing options from here

Scanning

Overview

There is a huge variety of scanners on the market and they cover a wide range of types and prices. In some ways, scanners can be thought of as static digital cameras: the images have to be brought to them rather than taking the camera to the image. However, their basic function is similar – to create digital images. When an image is scanned both the image resolution and the output size can be set and this in turn determines the overall file size of the scanned image. Unless you are interested in investing huge sums of money on a unit that would have the power to launch a space shuttle, the main options available are:

Make sure your scanner comes with TWAIN compliant software. This is a computing language that enables devices such as digital cameras and scanners to communicate with image editing programs. This means your image editing program can open your images directly from your camera, once it has been connected to the computer. Most editing software these days is TWAIN compliant.

- Flatbed scanner. This is the most common type widely available and their prices have fallen dramatically in recent years. Most of these scanners can copy a letter-size image or smaller and they operate in much the same way as a standard photocopier: the image is placed on a glass plate and then a light source is passed over it and the reflective image is captured by a Charge Coupled Device (CCD). The image can then be manipulated on a computer in the same way as one captured by a digital camera. The resolution of flatbed scanners is measured in dots per inch (dpi) and for a high quality scan you will need at least 1200 dpi

- Sheet feed scanners. These are scanners that allow a letter-size sheet, or smaller, to pass through the device in much the same way as it would through a fax machine. Although not as versatile as flatbed scanners they are a useful option if you just want to scan letter-size or smaller. Some scanners combine both the flatbed and sheet feed options within the same model. These are more expensive than those with a single option, but they are more versatile

- 35mm film scanners. This could be an essential option if you have a large number of slide transparencies that you want to add to your digital collection. These scanners are more expensive than flatbed ones and have a resolution from approximately 1200 dpi to 2750 dpi

Scanning images

Scanned images can be obtained through either the software
that came with the scanner or an image editing program such as
Photoshop Elements. To do this:

1. Access the Photo Browser and select the From Scanner option from here

If you are scanning an image for use on the Web, select a low output resolution (approximately 72 pixels per inch). If you are scanning it to be printed out, select a high output resolution (approximately 150–300 pixels per inch, or more). These settings for images can also be changed in an image editing program once the image has been scanned, but it is better to get it right at the scanning stage if possible.

2. Select the required settings and click OK

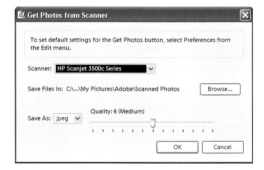

3. Settings can usually be selected for the specific scanner too – a window like this will appear

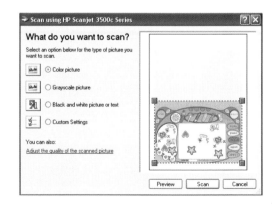

4. Click Scan to have the image scanned into a digital format and stored on your hard drive

Camera phones

Camera phones are becoming increasingly popular and they are now a common way for people to capture digital images. This chapter looks at the features of camera phones, how they function and how to capture, share and print images from this latest participant in the digital photography world.

Covers

Chapter Seven

About camera phones

The relentless march of technology has ensured that digital photography is no longer confined merely to cameras. One of the biggest developments in recent years has been the inclusion of digital camera capabilities in cell phones. Initially this was something of a gimmick, but the size and quality of images has now reached a level where this is a realistic, and convenient, way of capturing digital images.

The functionality of camera phones has improved greatly since they were first introduced and some of the features now include:

Removable flash memory cards are becoming much more common with camera phones. This enables a lot more images to be stored on the phone and it is also useful for printing images as most of the cards can be used in retail printing kiosks.

- Image resolution of over 1 megapixel i.e. over 1 million pixels in total (some cameras currently have an image resolution of at least 3 megapixels and even 7 megapixels for one model)

- Camera functionality such as zoom and, in some cases, flash

- Removable flash memory cards on which images can be stored

- Image editing capabilities within the camera phone itself. These are fairly basic but they do allow for functions such as cropping and simple color adjustment

It is also now possible to use these images in a variety of ways:

- Send them directly to other people with cell phones capable of displaying images

- Download them onto a computer as you would from a digital camera

The sharing service available from your camera phone will depend on your cell phone provider and the type of contract for which you have signed up.

- Upload them to an online sharing service

- Upload them to an online printing service to have hard copy prints created

- Print them directly via a retail photo kiosk. This is usually done by a wireless Bluetooth or infrared connection between the cell phone and the photo kiosk

Camera phone features

When looking at camera phones it is important to remember that they are not as sophisticated as digital cameras. However, this will change quickly as technology enables more features to be included within cell phones. One of the great advantages of a camera phone is that you are more likely to have it with you and so you will be in a position to capture more impromptu images that you might have missed by not having a digital camera with you.

When looking at camera phones it is important to decide whether the camera function is an important part of the phone, or just an accessory that you will use occasionally. If it is the former then it is a good idea to look for a phone that has as large a screen as possible as this will help for capturing and previewing images.

In the US, service providers for cell phones include AT&T Wireless, Cingular, Sprint PCS, T-Mobile and Verizon Wireless. In Europe they include O2, Orange, T-Mobile and Vodafone.

Other features to look for include:

- A zoom function. Some cameras have this option although it is not as powerful as on digital cameras. A camera phone with a 4x zoom would be reasonable

- An option for fitting an external flash unit. These are specifically designed for camera phones and give increased functionality for taking pictures indoors

- Night mode. This is an option for capturing images in low level lighting

- Sequence mode. This enables several images to be captured one after another

- Self-timer. As with a standard digital camera, this allows you to take images of yourself by setting the camera phone to capture an image after a certain time delay

Limitations

Although camera phones have advanced greatly since they were first introduced they still have a number of limitations, which include:

- Image quality. Although camera phones can capture images at a reasonable size (approximately 1280 x 960 pixels) the quality of the images is not usually quite as good as that of comparable images taken with a dedicated digital camera

- Lens quality. The quality of lenses in camera phones does not always match those of digital cameras. However, this is another area that is likely to improve rapidly

Regardless of the type of camera phone, you will still need a provider for the cell phone services, including those connected with sharing digital images.

- Focusing. Camera phones have limited focusing capabilities and most of them just have a fixed focus, rather than manual focusing or autofocus

- Metering. As with focusing, the light metering on most camera phones is relatively limited and does not offer a great deal in terms of adjustment. This means that you cannot alter the camera settings to take into account different lighting conditions. For instance, you cannot usually change the area of the image from which the light reading is taken. Expect improvements in this area in the near future too

Manufacturers

Some manufacturers to look at for camera phones include:

- Motorola at www.motorola.com

- Nokia at www.nokia.com

- Sendo at www.sendo.com

- Siemens at www.siemens.com

- Sony Ericsson at www.sonyericsson.com

Capturing and reviewing images

Capturing images

Due to the uncomplicated nature of camera phones, capturing images with them is a relatively straightforward process:

- Access the camera function on the phone. This can usually be done through the phone's main menu and it is also possible to put a shortcut button on the default screen to allow quick access to the camera function

- Compose the image using the phone's screen. If applicable, this can also involve zooming in on the subject, which is done using the phone's main control buttons

- Use the main control buttons to capture the image. Depending on the type of camera phone, it will then be saved either into the phone's internal memory or onto its memory card

Reviewing images

Once images have been captured onto a camera phone they can be reviewed in a single location, which serves as a gallery for all of the captured images. When images are being reviewed there are a number of things that can be done with them:

- They can be set as the wallpaper for your phone's background

- They can be sent to other camera phones

- They can be sent to an email address

- They can be uploaded to an online sharing service

- They can be stitched together to create a panorama

- With some phones they can have some basic editing functions applied to them. These include color correction such as brightness and contrast, cropping, adding text and adding frames around the images

Downloading images

Once images have been captured onto a camera phone it is useful to be able to download them onto a computer, so that they can be viewed on a larger monitor and also have more advanced editing techniques applied to them using image editing software.

All camera phones should come with a CD containing the software required to download images from the phone to a computer. Install this software when you buy the phone and you will then be able to download your images. To do this:

Bluetooth is a wireless technology that can be used to connect digital devices over short distances, approximately 30 feet.

1 Connect your camera phone to the computer using a USB cable or a Bluetooth connection

2 Open the camera phone software and select the required option (in

this example it is Transfer Files, which transfers the image files from the phone to the computer)

3 Locate your camera phone and select the location from where you want to download the images (the choice is usually between the camera phone's own memory or a removable memory card)

4 By default the
images will be
contained within an
Images folder on
the camera phone.
Locate this and
double-click on it to
view its contents

01032005(001) 01032005(005)

01032005(006) 01032005

5 Select the images you want to download and copy them to a
location on your hard drive in the same way as you would when
copying files of any other type

6 The camera phone
communicates with
the computer to
download the images

7 Once they
have been
downloaded,
the images
from the
camera
phone can be
viewed and
edited in the
same way
as any other
image files

Sharing images

Since digital photography has taken a secure grip in the consumer market there has been an increasing number of websites aimed at allowing people to share their digital images online. Traditionally, this has been done by uploading the images from computers, but a number of these sites now include a facility for uploading images directly from camera phones.

Online sharing services that also offer a facility for uploading images from camera phones include:

Depending on your camera phone service provider, it can be relatively expensive to upload and download images using a camera phone since the charges are usually made according to the amount of data transferred.

- One of the market leaders in this area, Kodak Mobile, which can be viewed at www.kodakmobile.com

- Snapfish at www.snapfish.com

- Dotphoto at www.dotphoto.com

When using an online sharing service with a camera phone you have to register for the service (registration is free) and you can then use the various services. These include:

- Uploading images from your camera phone to the online sharing service. To do this, select an image, or images, that you want to upload and send them via email to the email address of your sharing service

- Ordering online prints from your camera phone images, once they have been uploaded to the site. (Some sites that specialize in uploading images from camera phones offer a facility for printing the images directly from their site. Others, such as Kodak Mobile, have a related site that is used for ordering prints and similar items)

- Sharing images and folders with other people

● Downloading images from the online sharing service to your camera phone. The images can then be used as wallpaper on your phone. To do this:

1 Access your online sharing service and open an existing album

2 Access an image and click the Save as Mobile Wallpaper button

For more information about sharing online, see Chapter Twelve.

3 Click the Next button to follow through the steps for downloading the image to your phone. When it is completed you will be able to access the image on your cell phone and use it as your wallpaper

Save as Mobile Wallpaper
Preview your photo as mobile wallpaper, then click Next.
Credits available: 1

FREE Mobile Wallpaper!

The dimensions of your photo and the model of your mobile phone handset will affect how this picture will look on your phone.

Your first mobile Wallpaper is free so that you can preview the service and make sure it works for you.

Printing images

Images can be printed from camera phones in the same way as those from a digital camera: they can be downloaded onto a computer and then printed via a desktop inkjet printer or similar. They can also be printed via an online sharing service as described on the previous page and at retail outlets that have digital printing kiosks. If a camera phone has a memory card then this can usually be inserted into the printing kiosk and the images can be printed from it. Also, if the camera phone has Bluetooth or infrared (IR) capabilities the images can be uploaded wirelessly to the printing kiosk in this way. To do this:

- Turn on the camera phone and activate the Bluetooth or Infrared mode

- Stand in front of the printing kiosk and select the available options for downloading images wirelessly

- The images will be downloaded to the photo kiosk and printed at a size specified by you

Since the resolution and image quality of the majority of camera phones is still fairly limited, it is recommended that prints are ordered at a size of no more than 3"x4", to get the best quality.

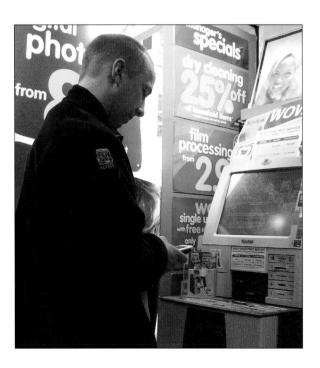

Photo kiosks are an excellent way to get prints from cell phones quickly

Image editing software

This chapter gives an introduction to the different types of image editing software on the market. It shows how the software operates and illustrates some of the effects that can be achieved.

Covers

Chapter Eight

Entry-level programs

When you start working with an image editing package, set up a directory, and sub-directories if necessary, for your images. This way you will always know where to go to find your images and you will not have to jump between different directories.

User interface

As the popularity of creating digital images via digital cameras and scanners increases, so too does the amount of image editing software. The majority of this is aimed at the general consumer market. For a reasonable price you should be able to buy a very solid editing package that will allow you to undertake a variety of editing functions and also apply some interesting special effects and touch-up techniques.

Entry-level editing packages are user friendly and the interface consists of easy-to-follow icons, toolbars and Help text boxes. Most also have their own libraries of images, which are useful for experimentation before you start creating your own. One of the best ways to get used to an image editing package is to use a copy of an image and experiment with as many of the different menu options and icons as possible. Even if the image ends up as a mess it will not matter if it is a copy.

The main functions available in the editing programs are:

All editing programs work best with the monitor set for the maximum number of colors that it can view (usually 16 million). Some programs will not function unless this setting is applied.

- Color editing. This includes adjusting the brightness and contrast, changing the hue and saturation, editing the shadows and highlights and amending color casts. In most programs there are automatic functions for color editing as well as manual controls

- Applying touch-up techniques. This includes actions such as removing red-eye, removing blemishes and altering images by cloning areas into or out of an image

- Creating special projects. This includes creating items such as greetings cards, calendars or slideshows, and burning images onto CD or DVD

- Sharing images. This includes emailing images or adding images to custom Web pages. In some cases, creative emails can be designed using images, ready to be sent using your own default email program

The programs

There are dozens of entry-level editing programs on the market but five of the best are:

- Photoshop Elements. This is the best-selling image editing program from Adobe. It offers extensive techniques for editing and enhancing images for both print and Web publication and it also has a range of tools for organizing and sharing images. It crosses the divide between entry-level programs and professional ones since it has the power of a lot of professional programs without the steep learning curve that some of them require. For more information, see the Adobe website at www.adobe.com

Some people use two or three different image editing packages, as they prefer particular programs for certain functions. This is a good idea and allows for more flexibility with your image editing.

- Ulead Photo Express. This is a popular program with beginners, with easy-to-use icons and a good range of functions plus some project options, although these are more limited than in Photoshop Elements. For more information, see the Ulead website at www.ulead.com

- Roxio PhotoSuite. This is another program in the Elements/Photo Express mode but with perhaps not such a wide range of functions. For more information, see the Roxio site at www.roxio.com

- Microsoft Picture It. This is a very easy-to-use program from Microsoft that offers a range of some of the most commonly used image editing techniques. For more information, see the Microsoft site at www.microsoft.com

Professional programs

Price and power

If you are prepared to pay several hundred dollars (or pounds) for an image editing program then you will get a product that should fulfil all of your imaging needs and more besides.

The professional models are designed specifically for designers, graphic artists and desktop publishing specialists. They are unsurpassed, both in terms of color editing functions and in preparing images for professional printing.

The main drawback of Photoshop is the price, which is aimed at the professional market. A more realistic option may be Photoshop Elements, the consumer version of the full Photoshop.

The main drawback with these programs is that they can seem complicated and difficult to learn. Some prior knowledge of image editing is useful, otherwise it may take intensive use before you feel comfortable with the software.

User interface

Unlike the general level programs, the professional versions offer very little in the way of guidance for users. The functions are contained within various toolboxes and menu bars and it is a case of trying each one to see what it does. When you are doing this, use a test image so that if you do something you are unable to correct you will not have wasted a valuable image of your own.

If you want to learn about a professional image editing program, make sure you have the time and opportunity to do so properly. It is not something that can be fitted around your normal daily tasks.

The programs

- Adobe Photoshop CS2. This is the top-selling image editing program and for power and versatility is it hard to beat. It is an excellent program for professional users, or those who are into digital imaging in a big way. For more information, see the Adobe website at www.adobe.com

If you want to unravel the mysteries of Photoshop or Paint Shop Pro then an excellent place to start is Computer Step's own titles: "Photoshop CS2 in easy steps" and "Paint Shop Pro 9 and Studio in easy steps."

- Corel Paint Shop Pro. For value for money this is one of the best programs on the market, and bridges the gap between entry-level and professional programs. For more information, see the website at www.corel.com

- Ulead PhotoImpact. PhotoImpact is similar in terms of power and functionality to Paint Shop Pro. For more information about PhotoImpact, have a look at the Ulead website at www.ulead.com

Opening images

Image editing software is the magic dust that transforms images by changing their basic elements (such as color definition, brightness, contrast and saturation), enables editing techniques that can alter or remove objects in the image, and adds additional elements to the image.

If you have never seen an image editing package before then the collection of buttons and icons can be a bit overwhelming at first. But, thankfully, most of these programs work on the same principles – you obtain an image from a selection of possible sources, you make your editing changes and then you print the image, email it or publish it on the Web.

Obtaining images

When you first open an editing program you will want to open an image so that you can work on it. On the higher-level programs you will just have the standard File>Open option. But with the entry-level programs you may encounter a screen that guides you through the process of opening images from a variety of sources.

Opening images from a digital device

Both Windows XP and Mac OS X have the means to recognize digital devices such as cameras as soon as they are connected to a computer. The images can then be downloaded directly into a folder within the computer. If the operating system does not recognize the type of camera that has been connected, then you will be given the option of loading the camera software (i.e. the drivers that enable the camera and the computer to communicate with each other) from the disc that came with the camera. If this is not possible, visit the website of the camera manufacturer and download the relevant drivers from there.

Most image editing programs also allow you to download images directly into them from the camera or another imaging device. They usually do this by providing a downloading wizard or an Import option such as this:

Viewing images

A view of 100% or 1:1 may not occupy the whole screen in some editing packages. This will depend on the size of the actual image rather than the viewing ratio. If you want to view an image on the entire screen then select the Fit to Window command, if there is one.

Once you have your image on screen, and you have congratulated yourself on getting all of the connections and settings correct, you can then decide how you want to view it. This will depend largely on what you want to do with it.

- For overall color editing, a Fit in Window setting is best. This means that all of the image can be seen on screen

- For editing that involves removing unwanted items, such as people or objects, a zoomed-in ratio of 2:1 or 3:1 is sufficient

- For very close-up work requiring individual pixels to be edited, a magnification of 10:1 or above may be required

Each program deals with magnification in a slightly different way, so experiment to see which settings suit your needs best.

If an image is viewed at a very high magnification it becomes pixelated. This means you can edit individual pixels, which can be useful for techniques such as reducing red-eye.

An image at 50% magnification

When performing very precise image editing tasks, such as cloning small areas or reducing red-eye, you may want to zoom in on an image using the maximum level of magnification available in your image editing program.

The same image at 400% magnification

File formats

Digital images can be created and saved in a variety of different formats. This is not always immediately apparent when you view the images on screen, but the file format can have important implications as far as the use of an image is concerned.

The two main areas that designers of image file formats consider are:

There are two methods for compressing digital images; lossy and lossless. Lossy means that some image quality is sacrificed, while the lossless method only discards image information that is not needed.

- The size of files – how to get good quality images that do not take up a lot of disk space

- The quality of images – how to produce images that give the best printed quality possible

Because of this, different file formats are better suited for some purposes than others.

RAW files

RAW is the description of image data that has not been converted into a specific file format and on which no in-camera processing has been performed. RAW format is mainly available with higher-end cameras.

RAW files can be edited with a program such as Adobe Photoshop. Since the data has not been processed in any way, RAW files can have some very sophisticated color corrections applied to them. Think of them as a digital negative of an image. After editing, the image can then be saved in a standard file format.

GIF files

GIF (Graphical Interchange Format) is one of the two main file formats that are used for images on the Web (the other being JPEG). It was designed with this specifically in mind and its main advantage is that it creates image files that are relatively small. It achieves this principally by compressing the image by removing unnecessary or irrelevant data in the file.

The main drawback with GIF files for digital images is that they can only display a maximum of 256 colors. This is considerably less than the 16 million colors that can be used in a full color image. Therefore photographs in a GIF format may lose some color definition and subtlety of tone.

GIF comes in two varieties, 87a and 89a. These are more commonly known as nontransparent GIFs and transparent GIFs respectively. With a transparent GIF the background can be made see-through. This is very useful for Web images: if you want the subject of an image to appear against the Web page background, you can do this with a transparent GIF.

Despite its narrow color range GIF is still a very useful and popular format. It is excellent for displaying graphics, and even photographs can be of a perfectly acceptable standard for display on the Web.

JPEG files

JPEG (Joint Photographic Expert Group) is the other main file format for Web images and it is the one that, as the name suggests, specializes in photographic images. A lot of digital cameras automatically save images as JPEGs.

JPEG images only achieve their full effect on the Web if the user's monitor is set to 16 million colors (also known as 24 bit). Most modern monitors are capable of doing this but, in some cases, the user may have set the monitor to a lower specification.

As with GIF, JPEG compresses the image so that the file size is smaller; it is therefore quicker to download on the Web. One downside to this is that the file is compressed each time it is opened and saved, so the image quality deteriorates correspondingly. When a file is opened it is automatically decompressed but if this is done numerous times then it can result in an inferior image.

The main advantage of JPEG files is that they can contain over 16 million colors. This makes them ideal for storing photographic images. The color quality of the image is retained and the file size is still suitably small.

PNG files

JPEGs tend to deteriorate the more that they are worked on and every time they are saved. This is because they are compressed during each save operation. If you are going to be doing a lot of image editing on an image, create it as a TIFF to do the editing and then save the final version as a JPEG.

The PNG (Portable Network Group) file format is a relatively new one in the Web image display market but it has the potential to become at least as popular as GIF and JPEG. It uses 16 million colors and lossless compression, as opposed to JPEG which uses lossy compression. The result is better image quality but a slightly larger file size. Since PNG is a developing format there are a few factors to bear in mind when using it:

- PCs and Macs use different PNG file types and, although both types can be opened and viewed on both platforms, they appear to their best effect on the platforms on which they were created

- PNG files can contain meta-tags – indexing information that can be read by Web search engines when someone is looking for your website

You should note the following file extensions (the last is the least common):

- *GIF files – .GIF*
- *JPEG files – .JPEG*
- *PNG files – .PNG*

TIFF files

The TIFF (Tagged Image File Format) format is one of the most popular and versatile currently in use. It creates files that have very good image quality and it uses a lossless compression system known as LZW (Lempel-Ziv-Welsh). This is the same system as is used by GIF images and it can compress files by between 50–90%, while still retaining the image quality. However, with TIFFs this leads to file sizes that are generally larger than GIFs or JPEGs, so they are used for files that are going to be printed rather than displayed on the Web.

When a file is saved to the TIFF format a dialog box will appear that allows you to specify whether you want to apply LZW compression or not. Unless you have a good reason not to, you should select this option.

Other file formats

Some other file formats you may come across when you are dealing with digital images are:

- BMP. This stands for BitMap Part and is a Windows format that has been popular in the past; however, it is generally now only used for specialist purposes

- FlashPix. This is a new file format that has been developed by a number of photographic and computer companies. The general aim of this format is to allow higher speed editing of large image files

- EPS. This stands for Encapsulated PostScript and is usually only used when files are being prepared for commercial printers

Kodak have developed a file format that is specifically for use with images on CDs. It is called Photo CD and can store images on a CD at five different sizes. Most image editing programs can open Photo CD files but they cannot save files to this format.

For your interest, you should take note of the following file extensions:

- *TIFF files – .TIF*
- *BMP files – .BMP*
- *EPS files – .EPS*
- *FlashPix files – .FPX*

There are other file formats for images but the ones discussed here are the most common.

Saving files

Most image editing packages have their own file formats (known as proprietary formats, see left) which they will automatically save files in, unless told otherwise. For instance, Photoshop and Photoshop Elements use proprietary formats with .PSD or .PDD extensions and Ulead has its own format with .TPX or .UPX. The main reason to use the program's file format is that it will generally speed up the editing process and it will allow any elements that are specific to that program to be applied to the image. However, if you will want to open the image in another program or place it on the Web you should select Save As and choose one of the commonly used formats such as GIF, JPEG or TIFF.

File formats that are unique to a specific program are known as proprietary formats. If you are working with these, then it is best to save a copy of the file into a more common format when you have finished editing. This way you can then open the file in another program if you want.

Most image editing programs have a variety of options for saving images, including for use on the Web

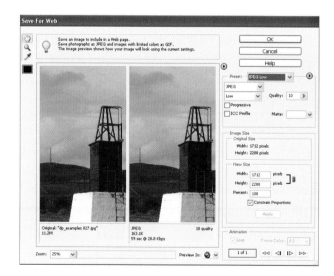

Some entry-level editing packages offer an icon-based interface for saving files. The professional packages will just have the standard Save and Save As commands and you then choose the file format and directory that you want.

It is possible to save the same image in numerous different formats. If you wanted to send a file to a printing bureau then you might save it as an EPS file, whereas if you were publishing something on the Web you could choose a JPEG format.

Quick fixes

Touch-up techniques go by a variety of names in entry-level programs but they all do the same general tasks – allowing the user to carry out operations like:

- Amending color appearance

- Amending image sharpness

- Changing image orientation

- Removing unwanted elements

- Converting the image into another format, such as black and white or watercolor

Some programs offer a variety of quick fix touch-up options within the same dialog box, like this one in Photoshop Elements:

Always make a copy of an image before you start changing the size, color or appearance. Then, if the editing does not turn out as expected, you still have the original to fall back on.

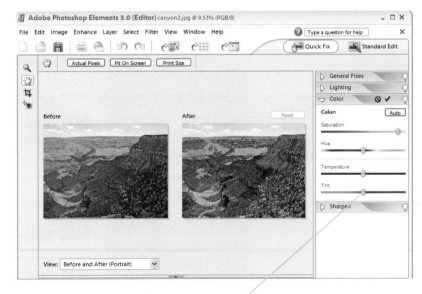

Drag these sliders to apply the changes for various quick fix functions

Effects and filters

As well as the standard editing techniques, image editing programs also offer a range of options that can best be described as special effects. Here is a selection:

If you intend printing your images once you have applied these types of techniques, always run off a draft version first – the printed version may look different from the on-screen one.

- Distortion

- Textures

- Re-coloring

- Edge Effects

- Collages

Special effects are usually available in filter or effects palettes within image editing programs.

Most filter and effects palettes have option boxes in which various attributes can be set for the filter or effect

If you are interested in a particular technique, such as embossing, then make sure the program has it before you buy. Most packages have a similar selection but there are some differences.

Types of project

Personal projects

One of the really fun aspects of image editing software is its ability to include images in a variety of fun, family-orientated projects. By following the on-screen instructions, your favorite images can be transferred to any of the following:

- Calendars

- Greetings cards

- Invitations

- Screen savers

- T-shirts

- Mugs

Programs such as Photoshop and Paint Shop Pro do not offer project options. So if you are interested in these then stick to the entry-level programs.

Always check to see which programs support the projects in which you are interested.

Most entry-level image editing programs have a range of special projects that can be completed using step-by-step instructions and pre-designed templates:

Creating projects

To create different types of project the process is usually fairly similar to this one in Photoshop Elements:

1 Select the type of project and select a style from the range of predesigned templates

2 Add your own images to personalize the project. Depending on the type of project there could be a number of steps involved in doing this

Organizing images

As you start getting more and more digital images on your computer it becomes increasingly important to be able to organize them so that you can quickly find the ones that you want. In Photoshop Elements this can be done by either adding tags to images or grouping them into collections. To add tags:

1 Click here to create a tag with a new name

2 Enter a name for the tag and click OK

Multiple tags can be added to individual images.

3 From the tag panel, drag a tag onto selected images in the Photo Browser. The tag will be added to the images

4 Click on a specific tag to view all of the images to which that tag has been added

To create collections:

1 Click here to create a collection
with a new name

2 Enter a name for the collection
and click OK

*Get into the habit
of organizing
images with
collections or tags.
As you obtain
more and more images it will
save a lot of time and effort
searching for a particular image if
you have already organized them
as efficiently as possible.*

3 From the collection
panel, drag a
collection icon onto
selected images in
the Photo Browser to
create a collection

4 Click on
a specific
collection
icon to view
all of the
images in that collection

Editing digital images

This chapter gives some editing tips and introduces some basic techniques for editing images, from color adjustment to removing blemishes.

Covers

Chapter Nine

The editing process

The ability of editing software to enhance digital images should not be seen as an excuse to take sub-standard pictures in the first place. Always try to take the best shot you can – a good original image will usually be preferable to a poor image that is digitally enhanced.

Although digital image processing is not yet at the level of a James Bond film, where a blurry dot on the horizon can be transformed into a crystal-clear image of a secret rocket launch pad, it can nonetheless achieve some dramatic effects on even the most humble snapshot. In addition to improving and tweaking the color of images, editing packages can also change the appearance of items, get rid of the demonic-looking red-eye and even remove unwanted objects in a picture.

When you are editing digital images you should consider two main areas:

- The overall look of the image, which is controlled by various color enhancing options

- The editing and special effects that can be applied to the whole image or to selected parts of it

Think of a digital image as a collection of colored dots rather than one complete picture. It is possible to edit each of the dots, either collectively or individually, or any variation in between.

The overall look of an image is concerned with whether it is too dark or too light, or if the colors look pale and washed-out. All of these areas can be improved with a few straightforward editing operations. For instance, if an image is too dark then it can be lightened with the Brightness command in image editing programs. This will lighten the image and a preview option will let you view the changes as they are made.

Special effect techniques enable you to add a variety of effects to an image and remove blemishes such as red-eye or scratches. This can produce dramatic results but you should be aware of the following points:

- Do not expect your images to be transformed beyond all recognition – the software can only work with what it is given

- Do not worry if your first attempts are not perfect. Persevere and you will improve

- Be as creative as you like – as long as you have saved a copy you can always go back to the start

Before you start

Editing digital images can be an extremely fulfilling task. Mediocre photographs can be transformed into images that you would be proud to show your friends and family and even use in items such as Web pages or newsletters. However, before you start sampling the delights of digital image editing software there are a few basics that should be followed:

If you make a mistake when editing, most image editing software has an Undo button. In some packages this only recovers the last action that you performed, while in others it allows you to retrace your steps for multiple edits.

- Digital images can be opened just like any other file on your computer. In most programs it is a case of selecting File>Open and then selecting the relevant file. Alternatively you can open an image using the Open icon on the toolbar

- Before you start editing any digital image, make a copy of it first. This way, if it all goes horribly wrong, you can still go back to the original and start again

- Have a good idea in your own mind of how you want the finished product to look. This way you can build up the effect slowly rather than trying to do the whole process too quickly. Think of it as being a bit like creating a storyboard for making a film

Even full-time photographers take dozens of shots to get one usable image. Don't be afraid to follow their example and then use the best ones for editing – after all, you aren't using up any film.

- Save your image frequently while you are editing it. Even though this should be done for all types of computer files it is particularly pertinent when you are editing digital images. The reason for this is that image files tend to be large and can cause computers to crash if they feel they are being asked to do too much processing. If this happens when you have undertaken a significant amount of editing then all of your work since the last time you saved it will have been lost. As a rule, save your image after every two or three edits. If this seems a little excessive, imagine how annoying it would be to have to go back to the beginning of your editing session and start again

- If you intend printing out your images then do this in draft at different stages of the editing process. Printed colors do not always look the same as those on screen. Remember: images on photographic paper display color to a higher quality than those on normal paper

Basic color adjustment

Most people who take photographs like to see the fruits of their labors in glorious color. The ability to produce images with striking and vibrant colors is a valuable one, but even if you take pictures where the color is less than perfect, image editing software allows you the chance to redeem yourself.

All imaging software has the tools to increase or decrease the main areas of color, such as brightness, contrast and saturation. This generally changes all of the selected color levels for the entire image. While this can produce effective results, there may be occasions when you need to lighten one area more than another, or increase the contrast on only one part of the picture. This can be done by selecting the area that you want to edit and applying the relevant color controls to that section. So if you have a striking image and a nondescript, washed-out sky, you can select the sky area and enhance it using your color controls.

The examples in this and the following chapter use Photoshop Elements. However, the theory is the same for all image editing software.

Fans of black and white images are also catered for in image editing software as the color can quickly be removed from images.

Editing software can be used to improve images, such as those that have a slightly washed-out sky

By adjusting the color of the sky the overall image is greatly improved

Brightness and contrast

The brightness and contrast of an image needs to be adjusted when the original picture is too dark or too light. This can be done by selecting the Brightness/Contract effect from your toolbox or Menu bar and then applying it to the image. There will probably be some type of sliding scale, where you can define the amount you want the brightness and contrast increased or decreased.

When you are increasing or decreasing the brightness or contrast, work with moderate changes, one at a time.

1 An image that is too dark would be of moderate value if it was from a film camera

Most editing software has a Preview function when you are editing an item. This allows you to see the effect before you apply it to the image.

2 Select the Brightness/ Contrast controls to edit the image

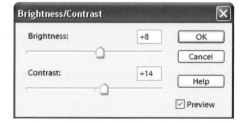

3 The final result is much more acceptable

Shadows and highlights

One problem that most photographers encounter at some point is where part of an image is exposed correctly while another part is either over- or under-exposed. If this is corrected using general color correction techniques such as brightness and contrast, the poorly exposed area may be improved, but at the expense of the area that was correctly exposed initially. To overcome this the Shadows/Highlights command can be used to adjust particular tonal areas of an image. To do this:

1 Open an image where one part is correctly exposed and another part is incorrectly exposed

2 Select the Shadows/ Highlights controls from the Menu bar

3 Make the required adjustments using the sliders or by entering figures in the boxes

4 Click OK

5 The poorly exposed areas of the image have been corrected, without altering the properly exposed part

Hue and saturation

Hue

The hue of an image refers to the tonal range of its colors. The hue of individual color channels in an image can be altered, as can the hue for the overall image. Changing the hue in an image can give some interesting, and at times surreal, effects:

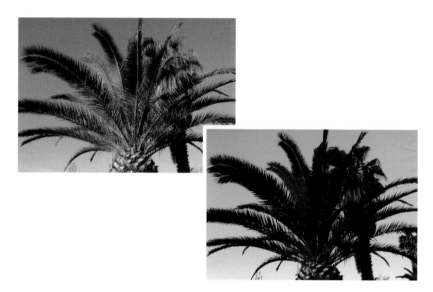

Saturation and lightness

Saturation and lightness increases or decreases the intensity of color in an image. In most editing packages this is done by dragging a sliding scale to add or remove color from your image. This can have a dramatic effect on images that appear slightly faded or washed-out. However, be careful not to overdo it or you may end up with images that look unnaturally bright.

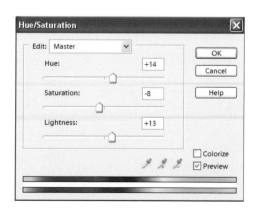

The hue, saturation and lightness can all be altered within the same dialog box.

Color variations

Using color variations is a quick way to see how an image will look if varying amounts of different colors are applied to it. To do this:

1. Open an image and access the Color Variations option

2. From the bottom of the dialog window, select a color variation to use for the image. The effect is displayed in "After" at the top of the window

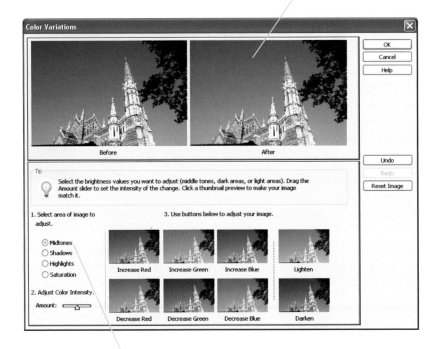

To apply a greater amount of each variation, click on the selected thumbnail several times.

3. Click here to select an area of the image to adjust. This can be the Shadows (dark areas), Highlights (light areas) and Midtones (the areas between the darkest and lightest colors)

4. Drag the slider to adjust the intensity of the color variation that is applied

Adjusting colors with Levels

In more sophisticated editing programs, such as Adobe Photoshop, colors can be edited using a function called Levels. At first sight the Levels option is one that looks more like something from a scientific experiment than a device that is going to transform your images. However, if you persevere with it then the results are more satisfying than those produced by the all-in-one editors.

The main difference between Levels editing and all-in-one editing techniques, such as Brightness/Contrast or Auto Fix, is that Levels allows you to change the settings independently for different areas (highlights, shadows and midtones) of the picture. Values for each element can either be entered into option boxes or altered using a sliding scale. This is a fairly technical way of editing your images and one that needs a fair degree of practice.

Do not expect to get the hang of the Levels command in a matter of minutes. It is vital that you make a copy of an image before you start applying this technique because you may well want to go back to the original.

Level controls can be altered by typing figures into the option boxes

Some editing programs have an Auto Levels command that adjusts all color aspects of an image in a single function. Although this can be quick and effective it is generally better to adjust each color element independently.

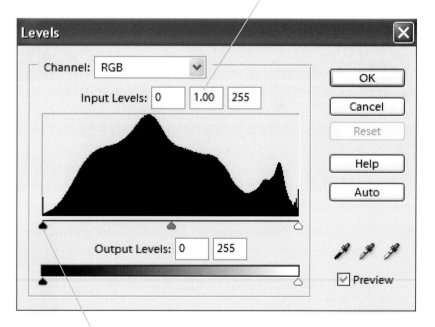

Tonal levels can also be adjusted by moving the sliding scales. This alters the color levels of the shadows, midtones and highlights. Experiment to see how this affects different areas of your image.

Selecting an area

For many editing functions it is necessary to select a specific part of an image. This allows for different techniques to be applied to separate areas of the picture. Therefore, tools to select parts of an image are a fundamental element of image editing software.

Rectangle tool

The standard tool for selecting an area of an image is a rectangle or an ellipse. To select an area, choose the relevant tool and click and drag over the required area.

The Rectangle tool can be used to select a symmetrical area within an image. This can then be edited independently of the rest of the image

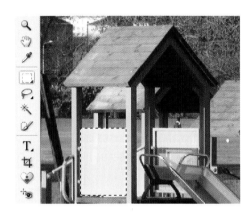

Freehand drawing tools are renowned for being notoriously jerky and difficult to use accurately. Allow yourself plenty of practice before you embark on a "live" project.

Freehand tool

The freehand drawing tool goes by a variety of names (Lasso, Trace or Freehand) but it does the same job: it selects irregular objects. To do this, select the tool and then trace around the area that you want to select. Don't worry if you include too much in your selection: this can be edited using feathering or cloning.

Some programs have a magnetic freehand tool which can be used to select areas by outlining them with consecutive straight lines. This can be a very accurate way to select irregular objects.

The Freehand tool can be used to draw an irregular outline around an object

Copying and pasting is very effective for creating symmetrical patterns, where one item is repeated several times.

Once an area has been selected there are various options available:

- It can be edited independently of the rest of the image. This is particularly useful if you want to apply an editing technique (such as blurring) to one part of the image

- It can be Copied and then Pasted back into the same image. This can be effective if you want to create instant duplicates like these:

1 Select an image and Copy it

If you are pasting a subject from one image to another, make sure that the background of the subject merges with the background of the new image. This can be done through the use of cloning – see page 143 for further details.

2 Paste the image to create a duplicate

- It can be Copied and then Pasted back into a different image. This is useful if you want to import a particular image into another application or if you want the image to appear against a new background

- It can be cut from the image altogether

- It can be dragged to another part of the same image

Cropping an image

Cropping is a technique that is frequently deployed in the reproduction of photographs in newspapers and magazines. It involves removing an area of the picture that is considered distracting or unnecessary. Now, with the wonders of digital editing software, this invaluable service is available to all digital photographers.

Different editing packages handle cropping in differing ways but the general procedure is:

1 Select the Crop tool

2 Drag around the area you want to keep

In some image editing programs you can crop images in specific proportions e.g. 10 x 8 inches or 7 x 5 inches. This is very useful if you want to print an image at a particular size: once it is cropped the image size will be amended accordingly.

3 Select Edit>Crop or Image>Crop from the Menu bar or press Enter

4 The unwanted part of the image is removed, leaving only the selected part

Touch-up filters

Even the most basic editing programs offer a wide range of effects and touch-up techniques that can be applied to your images. In some cases this is done by dragging the relevant icon over the image and then applying the chosen technique. In more advanced programs, filters are used to select the relevant options. This is done by selecting the area that you want the technique to affect, and then choosing the relevant filter. Some programs have up to 80 different filter options but it is unlikely that you would need this many.

Some digital cameras come with a reduce red-eye option. This usually works with varying degrees of success and it is not something that could be called an exact science.

Reducing red-eye

Anybody who has ever used a camera knows about red-eye, the condition where a perfect portrait is ruined because the subject comes out with menacing red eyes as a result of the flash reflecting in the pupils when the picture was taken. This still happens with digital cameras, but at least the software is now able to remedy it and give your subjects back their normal appearance.

The methods of reducing red-eye vary between programs but the fundamentals are similar:

1 Zoom in on the eyes

2 Select the Red-eye tool

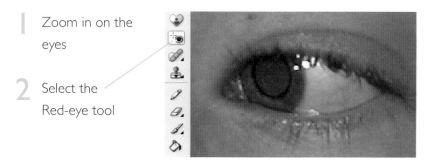

3 Click on the affected area to remove the red-eye

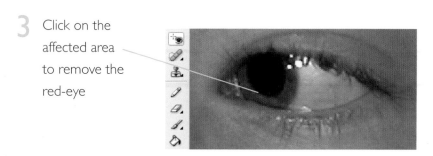

Sharpening

At first sight, sharpening appears to be the answer to every photographer's prayers: a tool that can improve and sharpen the focus of a blurred image. While sharpening can be a great asset to the digital image maker, it should not be seen as an excuse for not trying to take perfectly focused pictures in the first place. However, sometimes blurred images do occur and sharpening is one way to try to improve them. Even properly focused images can also benefit from sharpening.

The technical side of sharpening involves the editing software adding extra definition, or contrast, between adjacent pixels of different colors in an image. This makes those borders stand out more. Once this effect is applied to the entire image it gives it the appearance of being in sharper focus.

Some digital cameras have options for sharpening images when they are captured. However, this means that it takes slightly longer for the image to be processed within the camera.

A lot of digital images are slightly blurry when they are captured, although this may not immediately be apparent to the naked eye

Most software sharpening tools have the minimum options of Sharpen, Sharpen More and Sharpen Edges. The more sophisticated programs allow for manual sharpening by specific amounts and also provide the Unsharp Mask, which can create the best sharpening results.

Apply sharpening using an option such as the Unsharp Mask to improve the definition of the image. The change may only seem minor but it can greatly improve the image

Cloning

It is best to start off by removing small objects and then cloning the resulting holes.

As you perfect your technique you will be able to move on to removing larger objects, such as people and buildings. With larger objects you have to be careful to clone from several different points or else your seamless background will start to look like a grid.

One of the main items on a digital photographer's "wish list" is the ability to remove unwanted items and then fill in the resulting space with the same background as the rest of the picture. What was once thought of as belonging to the realms of science fiction is now perfectly possible with editing software and is known as cloning.

The cloning tool works by duplicating pixels next to the selected area. You select the pixels you want to use as your cloning pixels by clicking on them with the cloning tool. Then, with the mouse held down, you move the cloning tool over the area that you want to change. The effect is similar to painting over a picture with a different color.

One of the main uses for cloning is for removing blemishes and unwanted marks. This is the type of technique that magazines use frequently to make their models look as perfect as possible (which gives a modicum of reassurance to the rest of us). In this instance a mole or wrinkle is covered up by cloning the area of clear skin next to it.

Cloning can also be used to remove irritating features such as blemishes, scratches on the image and specks that may appear on your picture. Always zoom in on the affected area.

If an image has minor blemishes (such as spots), these can be removed by cloning the area next to them

Cloning tools can be selected in a variety of sizes (thin to thick) and are used as an artist would use a brush to fill in a gap in a painting.

Cloning can also be used to copy or remove larger objects from an image, such as people or buildings:

1 Open an image containing elements that you want to clone

2 Select the cloning tool

3 Select an area that you want to use as the cloning area

4 Drag the cloning tool where the cloned image is to appear

5 Once the cloning is completed the rest of the image can be edited if required

Removing blemishes

When capturing images of people there is always the chance that they would like to improve their appearance by removing blemishes such as wrinkles and spots. With image editing programs this can be done with tools such as the Healing Brush or the Spot Healing Brush. The former can be used to remove blemishes over larger areas, while the latter is better for small blemishes such as spots. The Healing Brush and Spot Healing Brush tools create a similar effect to cloning, except that it can be more subtle for areas such as skin tones as it blends the area being copied with the target area. To remove blemishes in this way:

1 Open an image and zoom in on the area with the blemish

2 Select the Spot Healing Brush tool from the Toolbox and make the required selections in the Options bar

3 Drag the Spot Healing Brush tool over the affected area

4 The blemish is removed and the overall skin tone is retained

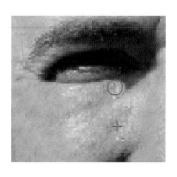

Noise

Noise can be caused by a lack of light on the subject when the picture was taken; it gives a grainy result. Noise can be edited out using image editing software, but the end result is not always perfect. Alternatively, noise can be added to create an artistic effect.

To remove noise from an image:

Noise can also be generated if a high ISO equivalent rating is used, usually in the range of 800 or 1600.

1 Open an image that contains noticeable noise

2 Select Filter> Noise>Despeckle from the Menu bar

Noise can also occur during the process of capturing an image on the camera's image sensor and then transferring it to the camera's memory card. Generally, the better the camera, the less chance of high levels of noise occurring.

3 When the noise is removed the image appears smoother but can seem slightly blurrier. However, when the image is viewed at normal magnification it will appear sharper

Further editing options

There is a wealth of options available within digital image editing programs. This chapter takes a look at some of them including: using layers, adding text and color, repairing damaged photographs and creating panoramic views.

Covers

Chapter Ten

Using layers

Layers, which are supported by some image editing programs but not all of them, allow the user to create multi-layered images that are built up with different image elements and items such as text.

Layers are a very useful way to add elements to an image without altering the original image – new elements are placed on top of the base image. An individual layer can be edited without affecting any other layers in the image.

Layers are controlled by the Layers Palette:

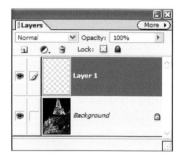

Some programs do not have a layers option. If you think you will be using this a lot then look at one of the Adobe products, or Paint Shop Pro or PhotoImpact.

An original image starts off with only a single layer. However, if text is added to the image this is automatically added as another layer. Once the text has been placed on the image it appears on the Layers Palette. This can then be edited at any time, if desired, by selecting that layer from the Palette.

Added text is placed on its own layer

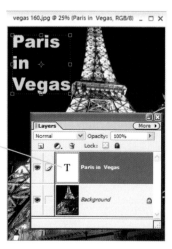

Up to 99 layers can be used in one image and these can be included:

- By dragging another image onto the active image

- By dragging a layer from another image

- By pasting an image that has been copied

- By using the Layers Palette

Layers are a very useful device for creating collages because you can include numerous items in the image and you can edit all of them independently of each other.

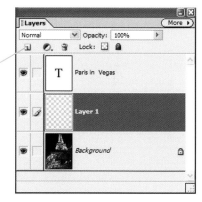

To create a new layer, click here in the Layers Palette

When a layer is added to an image it goes on top of the ones that are already there. However, it is possible to edit or re-order individual layers by selecting them in the Layers Palette. You can also merge layers, but this should only be done once the entire editing process has been finished.

Each time you add a new element to an image, try to include it on a different layer.

Layers are an excellent way to create complex images and can result in interesting effects

Creating collages

Collaging is a technique that involves taking elements from two or more images and combining them into a new composition. This can be done to create a humorous effect by setting two incongruous items together or as a photomontage to accompany an article in a newspaper or magazine.

Collages can be fun, informative or outrageous

Although collages can be very effective, the following should be remembered:

Collages represent a useful technique. Some uses include: putting subjects against different backgrounds; swapping heads onto other bodies; adding extra elements to faces; combining two objects to give an unusual perspective.

- Use collages sparingly. If they are used frequently then their impact will be lessened and the effects will be wasted

- Plan your images beforehand (if possible) if you are going to be creating collages. For instance, if you want a collage of someone leaning against the top of a tall building, take one shot of the building and another of the individual leaning with their arm outstretched. This will make the editing a lot easier

- Make it obvious that the collage is not an original single image. Do not use them to mislead people

- Do not use collages to put people in embarrassing or compromising positions

Once you have the images that you want to include in a collage you can create it with the following technique:

1 Open the images you want to use to create the collage

2 Use a selection tool to select the first object

3 Copy the selected object and paste it into the second image

4 Resize the object and make any minor adjustments such as editing the overall color or cropping the image. Erase any parts of the pasted object that would naturally be hidden by foreground objects in the second image

Panoramas

Any photographer who has ever stood in front of a majestic panorama of scenery is likely to have several photographs that have been taken in series to try to capture the full sweep of the view. Newer APS (Advanced Photo System) cameras have a setting that does this in one image, but digital photography goes one better by combining several pictures into one image:

When capturing images for a panoramic image, do so with the same exposure for each one. This can be done by locking the exposure using the on-camera settings.

Some standard image editing packages, such as Photoshop Elements, have the capability for creating panoramas and there are also dedicated software packages for this purpose, such as Panoweaver (website at www.easypano.com) or Ulead Cool 360 (website at www.ulead.com).

When creating a panorama there are a few rules to follow:

Some digital cameras have a panorama setting whereby you can create the panorama within the camera rather than taking individual images and then stitching them together in the software.

- If possible, use a tripod to ensure that your camera stays at the same level for all of the shots

- Make sure that there is a reasonable overlap between images. Some cameras enable you to align the correct overlap between the images

- Keep the same distance between yourself and the object you are capturing. Otherwise the end result will look out of perspective

- Keep an eye out for unwanted objects that appear in the panorama

Stitching functions in much the same way as manually creating panoramas: select your images, put them in order and then stitch them together. Practice may be required to get exactly the desired effect but the basic technique is:

1 Capture the images that you want to make into a panorama

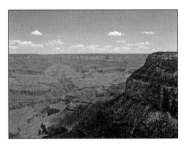

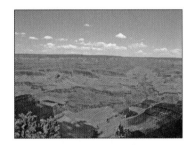

2 Add the images to the Photomerge window

3 The images are merged into one and this image can be saved in the same way as any other

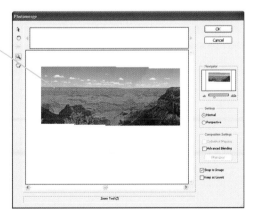

Adding text and text effects

Adding text to digital images is a straightforward and effective way to personalize them and add individual messages. When you add text you begin by selecting the Text tool. The text formatting options can be selected before the text is added, or existing text can be formatted once it has been added to an image. Once it is on the image it can then be moved around and edited. To add text:

Do not add too much text to an image. It can make it appear cluttered and draw attention away from the image itself.

If you are adding text, make sure that there is a good contrast between the text color and the background. Some colors, such as yellow, do not always show up very well as text.

1 Open an image

2 Select the Text tool

3 Select formatting options

4 Click on the image at the point where you want the text added. Type to add the text

Creating text effects

It is also possible to create interesting text effects to give text an added dimension. To do this:

1 Add text to an image as shown on the previous page

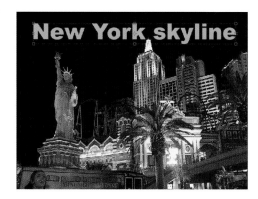

2 With the text selected, select the Warp Text option from the Text options bar. Click here to select a style for the text effect and click OK

3 The selected effect is applied to the text

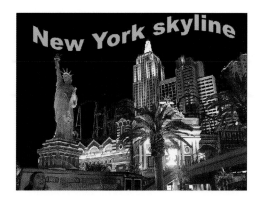

Adding colors

You can paint additional colors onto an image in much the same way as adding text. This can be useful if you want to change a background element, such as the color of the sky, or alter the color of a piece of clothing.

To add additional color to an image:

1 Open an image

2 Select the Paint Bucket tool or the Brush tool

Use small brush sizes for adding precise details to colors and a larger one to cover big areas.

3 Select the required color in the Color Picker and click OK

When you are adding new colors to an image, try to make sure that they blend in well with the ones that are already in the image.

4 Color the image by clicking on an area with the Paint Bucket tool or by dragging with the Brush tool

Adding gradients

Gradient color effects can also be added to images or selected areas within them. To do this:

1 Select an area within an image

2 Select the Gradient color tool

3 Click here to select options for the gradient effect

4 Apply the gradient effect by dragging within the selected area of the image

Repairing old photographs

Image editing software is an excellent option for restoring the quality of old photographs or ones that have been torn or crumpled. In order to do this you have to get them in a digital format for the editing process. This can be done by:

- Scanning the photograph. This is the best option and if you do not have a scanner yourself then it could be done by a color-copy print shop. Try to get the original image scanned as large as possible as this will make it easier to work with

- Capturing an image of it with a digital camera. This works best if you have a macro close-up facility

If you want to restore an old photograph it can be made to look even more realistic by adding a sepia tint to the image. If the editing package has this facility it is usually found in the touch-up toolbox or menu.

Image editing software can make dramatic improvements to images that are faded, torn or scratched. This is particularly useful for old black and white photographs

Before you start removing tears and lines from the image there are a number of steps that you can take to improve the final image:

- Adjusting the color and contrast

- Applying a neutral background. This can be particularly effective if the picture is a portrait that has been taken against a plain background. If this is full of blemishes then it would be a lengthy task to correct all of them. A better idea is to select the subject, copy it, and then paste it into another file

...cont'd

Once you have a digital image of the old or damaged photograph it can then be edited using the following procedure:

1 Adjust the color and contrast

2 Zoom in on the affected area

If you want to repair a damaged print properly, it is essential that you take your time. In all probability you will have to clone numerous different areas to cover all of the blemishes and this is a task that will have to be performed dozens of times in order to cover all of the different colors of the image. It will probably also be necessary to work with the Cloning tool set to a small size so that you can zoom in and work in close-up.

3 Select the cloning tool and the area to be cloned. Repeat this with all of the affected areas

4 Once all areas of the image have been repaired, adjust the color and contrast again

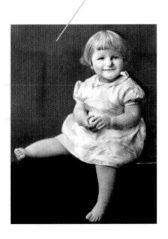

10. Further editing options **159**

Effects and distortion

Also known as Filters in some programs, special effects and distortions can be used to alter images in a variety of ways. This can include changing the physical appearance of an image (for example by adding a sphere distortion effect) or adding color effects (such as a colored pencil effect).

The basic editing function of effects and distortion is straightforward: you open an image and then you select an effect that is automatically applied to the image, or to a selection within it. Other effects have dialog boxes into which values can be entered to adjust the level of the effect. This is useful as it offers a greater degree of sophistication when applying the effect. To do this:

Try not to overdo the amount of distortion that you apply to images. This may produce what is a striking image to you, but someone who is not so familiar with it may not be at all sure what the image is.

1 Open an image and double-click on a Filter effect in the Filters Palette

With a little planning and organization it is possible to apply special effects that create an imaginative and eye-catching image, rather than just a humorous one. The key to success is to experiment with the special effects first and then think of images to capture that will best complement these effects.

2 Make the required selections in the dialog box and click OK. The effect will be applied to the image, or to the area currently selected

Blending images

Blending is a technique that enables two or more images to interact with each other, as long as they are placed on two separate layers within a new file. To do this:

1 Open two images. Select the entire area of the first image and copy and paste it into the second image. The two images will appear on separate layers in the Layers Palette

2 Click here to specify an option for how the two layers in the new image interact with each other

3 Experiment with the different blend options to see how they affect the two images

Creating opacity

The opacity of a layer can be set, to determine how much of the layer below is visible through the selected layer. To do this:

1 Select a layer in an image

2 Click here and drag the slider to achieve the required amount of opacity for the selected layer. The greater the amount of opacity, the less transparent the selected layer becomes

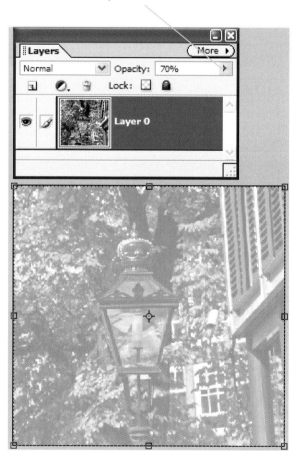

 For watermark effects, try setting the opacity level to 20%–30%.

3 Changing the opacity can be a good way to create watermark effects in an image and it is an excellent option for creating backgrounds upon which other items can then be placed

Obtaining prints

The printing process is an integral one in digital photography. This chapter looks at some of the options available and how to obtain the best printed images possible.

Covers

Chapter Eleven

The printing process

Color printing is one area of modern technology that has advanced as much as any in recent years. What was once the domain of professional printers, or a select few who could afford expensive color printers, is now available to anyone with a spare $100 or more to spend.

It is not essential to know exactly how each type of printer works to produce the end result but it is useful to know a bit about the methods they employ. The two main forms of color printing are:

- Halftone printing

- Continuous tone printing

When you are dealing with halftone printers the term "separations" may come up from time to time. This refers to the individual color screens that the process creates. These are usually combined to create the overall image but they can also be printed out individually. If you are working with a commercial printer they will probably ask to see color separations of your images.

Halftone printing

Also known as screening, this is the method used by inkjet and laser printers. The image is created by printing a series of dots, or screens, that create the illusion of being a continuous image. However, if you look closely at a halftone image you will be able to see the individual dots of color. As the technology improves it gets harder and harder to identify the dots and when the image is looked at from a normal viewing distance the halftone patterns should not be visible to the naked eye. One problem that can occur with halftone printers is that, if the different screens are not lined up properly, the final image will suffer from shadowing and the colors will not look entirely accurate.

Halftone printers usually work on the CMYK (Cyan, Magenta, Yellow, Black) color model while continuous tone printers generally employ the RGB (Red, Green, Blue) model.

Continuous tone printing

This is the method that produces the closest output to true photographic quality. Unlike halftone printing, there is no separation between the color elements of the image and so each part of the image merges seamlessly into the next. If you examine a continuous tone image carefully you will not be able to see the colored dots in the same way as you can with a halftone image.

Continuous tone printing is done by devices such as dye-sublimation printers and it is the route to take for the best images. There are increasing numbers of these printers now appearing on the market, but they are more limited in the size of prints they can produce.

Printer resolution

As with digital cameras, the resolution of an inkjet printer is one of its main selling features. Resolution for printers of this type is measured in dots per inch (dpi) and, as a rule, the higher the better. Some inkjets currently on the market can print up to 5760 dpi. However, it should be remembered that the printer resolution does not affect the size of the image; this is done by the image resolution setting in the editing software. To recap:

- One measure of image resolution is the number of pixels per linear inch and this can be set within the image editing software. So if an image is 1200 pixels wide and you want a printed image that is 4 inches wide then the image resolution should be set at 300 ppi (pixels per inch)

- Printer resolution is not the same as image resolution. Printers have a range of resolution options for printing images, for draft or high quality results. If a printer prints at a higher resolution it recreates each pixel using more colored dots of ink. This increases the quality but does not affect the overall size of the image

Image resolution can be selected within image editing software and this is what determines the final printed size:

At different resolution settings within editing software, an image will be printed at different sizes. The higher the print resolution, the smaller the size of the printed image

Printer settings

One area that is often overlooked when outputting color images is the range of printer settings that can be adjusted via your printer software. All printers come with software that enables them to communicate with a computer and vice versa. In the computer world these are known as drivers, which makes them sound more like a piece of hardware, but they are in fact software.

Adjusting settings

Printer settings can be adjusted when you select Print or Print Setup from whichever program you are working in.

Take some time to experiment with different printer settings for your images. They do make a difference and it will increase your confidence in the overall editing process.

If you print your images by selecting the print icon that appears on most toolbars then the printer will use the current print settings. If you want to change anything you will have to do it via your Print dialog boxes or a program such as Print Manager.

A standard print setup box. This enables the user to make selections for how an image is printed, including options for the quality of the image and the type of paper being used

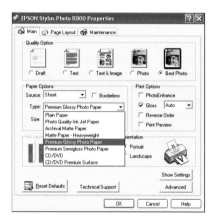

Page Layout options can be used to specify the printing options such as the number of copies, reduction or enlargement of an image to fit on the paper and whether the image is printed with a watermark or not

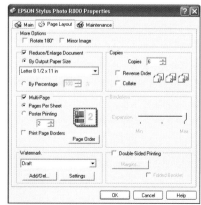

Maintenance

When printing digital images, it is important to keep your printer in as good a condition as possible. Within the printer software there is usually a dialog box for performing a variety of maintenance tasks. This can usually be accessed from within the print setup options. The maintenance options usually include checking the amount of ink left, checking the condition of the printer nozzles, nozzle head cleaning, and aligning the print heads to get the most accurate print possible.

The maintenance options can usually be accessed from the tabs along the top of the print setup dialog window

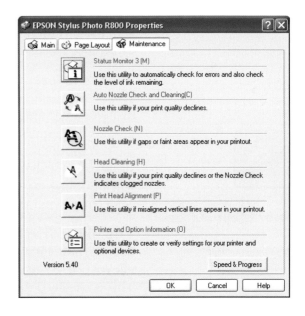

Printing speed

The larger the image, the longer it will take to print. If you want full Letter-size output then this will take a lot longer than for a standard 6" x 4" photo-size print.

If you want to get the highest quality of print, on the best paper, the output figure is more likely to be in terms of minutes per page rather than pages per minute. However, for most people who are printing images this does not really matter. Quality certainly beats speed in this case, and so be prepared to wait if you want sharp images. If you also need a printer to produce textual documents then the print speed may become more of an issue. There are some printers on the market that are designed specifically for text and images, but if you are only going to be printing photographs then look for a printer that specializes in this.

Inkjet printers

If you want to use digital images for anything more than displaying on a Web page or a monitor then a good quality color printer is essential. Without it, the images from the highest resolution camera could look grainy or slightly blurry.

Always allow color prints to dry thoroughly before you handle them. Depending on the size of the print and the paper, this could take from a few seconds to a couple of minutes.

The most common type of affordable color printer on the market is generically known as the inkjet printer. This was a name that was first coined by Hewlett Packard to describe a particular printing process and it has since spawned numerous imitators. Two other companies, Canon and Epson, use a similar method but they apply different names: bubblejet for Canon and micro piezo for Epson. Although the technology differs slightly between the three, they are all usually grouped together under the term inkjet.

What's it for?

What you intend using your printer for may determine the type that you buy. Some color inkjets are designed specifically to produce high quality color images. They can also print text, but the text quality is not as good as that from a printer designed specifically for that purpose. They also tend to be less economical when printing text. Other printers go for a combination of good color images and text.

For photographs, there are specific photo printers that produce the highest quality results. They can also be used for non-photographic color pages.

The inkjet method

Inkjet printing is essentially a simple process: tiny dots of colored ink are placed onto paper by a collection of miniature nozzles. This is usually done with two cartridges, one containing black and the other containing cyan, magenta and yellow. When they are combined they create the CMYK (K is for black) color model.

Most inkjet printers now have individual cartridges for each color used, instead of having four contained in one cartridge. This can make them more economical as you only have to replace a single cartridge when that color runs out rather than the whole color cartridge.

Some color printers only have a single cartridge and this usually results in inferior color quality. This is because they cannot produce the same range of colors and their version of black is not true black, more like a murky brown. Always go for printers that have at least two color cartridges.

A handful of more recent inkjet printers have an additional two, or four, colors (lighter shades of magenta and cyan) as well as the four in the CMYK model. This increases the range of color variations available and is effective for subtle color changes such as in skin tones.

Other types of printer

Dye-sublimation

An increasingly popular type of printer for color images is the dye-sublimation variety. Also known as the dye-sub or thermal-dye printer, this is one option that is worth considering if you are only interested in making high quality color prints. Dye-sub is a process that heats various colored dyes in such a way that they are fused onto the paper. Unlike the halftone effect of inkjet printers, dye-sub printers create a continuous tone image in which individual dots of color cannot be seen. This gives an excellent end result and is probably the closest you will currently get to traditional photographic standard.

Consumer-level dye-sub printers are generally more expensive than their inkjet equivalents and the price-per-page is higher than with an inkjet printer. Also, you do not always have the option of printing in draft quality.

One recent feature of dye-sub printers is the ability of some of them to be able to generate prints directly from a digital camera, as well as printing from a computer. The camera is connected to the printer and a hard copy can then be produced. While this is a useful feature, it removes the editing element so you have to make sure that your pictures are exactly right when they are captured.

One downside of dye-sub printers is that the consumer-level models are sometimes restricted in their output size and they do not handle large volumes very well. Also, dye-sub printers can only be used for printing images. So if, like most of us, you want to print text on occasions, you will need another printer to do this.

Thermal wax and micro dry

Thermal wax printers use a similar heat method to dye-sub but are cheaper for running costs. Micro dry printers also use heat to affix color to the page but in this case it is done through ribbons coated with special inks. This gives a good quality at a reasonable price.

Laser

As a rule, laser printers are faster than inkjet ones and provide high print quality. However, their main drawback is cost, particularly for color printing. Unless you are willing to spend a lot of money, color laser printers are best left for the office or professional print bureaus.

Selecting paper

Paper types

While one piece of paper may look similar to another, the differences can be considerable when it comes to printing photographic images. Some inkjet printers can give good results on plain office-type paper, but if you switch to a type of paper specifically designed for color images then you will notice the difference immediately.

Some of the various paper types available include:

If you want the best print results then go for the best products: a high resolution photo printer, photographic quality paper and branded ink to match your make of printer.

- Standard multi-copy paper. This can be used in inkjet printers, laser printers, fax machines and photocopiers. It is very versatile but gives the poorest quality for photographic images

- Inkjet paper. This is a step up from multi-copy paper and gives good color results on inkjet printers. It is useful for printing items such as company reports that have colored charts and similar images

The reason that glossy photographic paper can produce results which are so much better than ordinary multi-copy paper has to do with the coating on the surface of the paper. It is designed to grip the ink more securely so that there is less chance of individual dots blurring into each other.

- Photographic quality paper. This is a term for glossy paper that produces results as close to photographic quality as you are going to get from an inkjet or laser printer. It is the most expensive type of paper and within this range there is a considerable selection from the main companies such as Epson, Kodak, Hewlett Packard, Agfa, Canon and Ilford. Photographic paper comes in different qualities, depending on the weight. For the best prints, use the heaviest weight of photographic quality paper that you can find

- Matte photographic paper. This is the highest quality photographic paper, to be used when quality is paramount

Experiment with different types of paper to see which is the best for the job you are doing.

Other printing options

Although the most common paper format is Letter-size this is by no means the only option available. Depending on the type of printer, the following media and formats can be used:

- Large format paper. Only certain printers support this format and they are inevitably more expensive than the standard models. However, this is a great way to create poster-size prints in sizes such as A3

If you are printing images for an OHP presentation, make sure that they are sharp and clear once they are projected onto a screen. In some cases, color definition and image detail may be lost.

- Film transparencies. These are sheets of clear plastic that can have images printed on them for display on an Overhead Projector (OHP). This can be very useful for business presentations and if you have some of your own images it will make a pleasant change from the ubiquitous Clip Art

- Cards. Images can be printed on specially sized cards. You can also print them onto Letter-size paper and then cut them to size, but if you want a professional finish this is a useful option

Branded or generic

Each printer manufacturer has their own brand of photographic paper and they all insist it is the one that works best with their own unique printing system. But there are a lot of other companies that produce photographic quality paper that is also of a high standard.

One of the main considerations when buying paper may be the cost. The top quality paper is not cheap and you can sometimes save money if you buy paper from companies other than the printer manufacturers. Shop around and test different paper types. It may take a little time until you find a good combination of price and quality.

If possible, buy paper in bulk as this can work out considerably cheaper in the long run. However, always check the quality on your own printer first, before you commit yourself to a large order: if you make a mistake it may be a costly one.

Ink issues

Manufacturers of color photo printers have worked tirelessly in recent years in order to be able to create printers that can produce photo quality prints for the general consumer. With the current top-of-the-line printers this is now possible – it has been achieved by a number of advances in printer technology and also in the way ink is used in the printing process. Modern color photo printers use either four or six cartridges of ink when printing digital images. One of these is always black, which means that the other cartridges contain either three or five colored inks:

Three ink color cartridges

A printer with three colored inks contains cyan, magenta and yellow. These are mixed with the black cartridge to create a four color printing system that can produce reasonable quality output for digital images.

Five ink color cartridges

A printer with five color ink cartridges contains cyan, light cyan, magenta, light magenta and yellow. The two additional colors allow for a lot more variation of tone and this can produce excellent results, particularly for skin tones and areas of subtle variation. If possible, look for inkjet printers that use a six ink process i.e. five colors and black. Some more recent printers now include up to eight cartridges in total, which include a gloss optimization cartridge to make the prints look as shiny as possible.

Dealing with fading

It is a fact of digital life that images printed on inkjet printers will fade over a period of time. If an image is kept away from direct sunlight then it can survive for several years before it starts to fade. However, in direct sunlight the fading process may be a lot quicker. This is another area in which a lot of investment has been made by printer manufacturers and the life-span of printed digital images is increasing continually. In some cases the manufacturers claim that the ink will not fade for several decades, as long as the correct type of paper is used.

One way to lengthen the life-span of your images is to spray them with water-fast sprays that are available in art supply shops. This gives the image a certain amount of general protection and some sprays also give a degree of protection against sunlight.

When you change cartridges in your printer, make sure you realign the print cartridges. This is done via the printer options and is particularly important for photo cartridges – if the alignment is even slightly out then this will affect the color of your printed image.

Always keep copies of printed images on your hard drive or a backup device. This way, if they do fade you will be able to print out more copies.

In-store prints

As digital photography gains in popularity the printing world has not been slow to embrace the possibilities that this presents in the way of printing color images for customers. The issue of simplicity, or otherwise, has been a major factor in obtaining prints of digital images but things have improved greatly and it is now possible to get excellent quality prints at reasonable prices from in-store processing. In addition, most film processing and printing companies will save your digital images onto a CD, if required.

If a film processing retailer has a digital printing service they should be able to print images from most digital media, such as camera memory cards, floppy disks and CD-ROMs. If in doubt, check first before you make the trip to the store. Some companies that offer in-store printing are Canon, Kodak and Fujifilm.

Some companies, such as Kodak and Canon, offer online digital printing. The images are emailed to them and they create the prints and send them back to you in the mail. For more information on this, see Chapter Twelve.

Professional print bureaus can also be used to get high quality prints. This can be expensive so only use bureaus for top quality professional work. Before you commit yourself, talk to them about your, and their, requirements.

Digital kiosks offer instant printing and they can print from all types of flash memory cards, CDs and also cell phones with infrared (IR) or Bluetooth connections

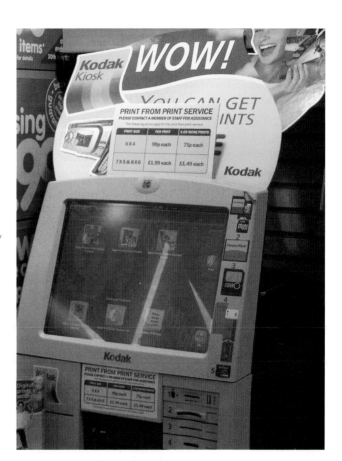

Printing checklist

Since the printing process is, in some cases, the final one that will be applied to your images before they go on view to the world, it is worth following a checklist for achieving the best results:

- Choose an inkjet printer for a good combination of quality, price and versatility. These are the most commonly available printers and it is possible to find them sold in packages with many computers these days

- Choose a dye-sublimation printer for high quality images at reasonably small sizes

- Check the price of consumables (ink, paper etc.) when looking at printers

- Dots per inch (dpi) refers to printed output levels. Printers are usually advertised as having a headline dpi output figure

- The size of your final image will be determined by your image resolution. This is set by the image editing software. Use 150–300 pixels per inch (ppi) as a standard print resolution with the image editing software

- A high resolution of printer (dpi) improves the quality of the printed image as it uses more colored dots to print each pixel

- Use normal paper and a draft quality setting on your printer for preview prints of your work

- Use heavy photographic-quality paper and the highest quality print setting for your final prints

- Use a protective coating on your images before you display them. This will increase their longevity

Sharing images

Displaying, sharing and printing images online is one of the great growth areas of digital imaging. This chapter looks at how to share images over the Web and how to get prints from online services. It also covers using images creatively online and looks at portable devices for storing digital images.

Covers

Chapter Twelve

Online sharing

A lot of online sharing services also offer printing facilities for images that are uploaded to the site.

As digital photography has become more popular, one of the issues that the digital imaging industry has had to confront is how to enable users to distribute their images effectively online. One solution has been the introduction of online sharing services. These are websites that allow users to upload their images into an area on the site and then invite selected people to view them. These services are usually free and they have the advantage of allowing the owner of the images to restrict access, permitting only chosen people to see them. There are dozens of online sharing services on the Web and some to look at include:

- Kodak at www.kodak.com

- Club Photo at www.clubphoto.com

- Dot Photo at www.dotphoto.com

- Snap Fish at www.snapfish.com

The method of operation is similar on all online sharing services:

If you are asked for any type of fee for using an online image sharing service, then look elsewhere.

1 Access the site's home page and register for the site. This is usually free and only involves entering your name and email address

2 Once you have registered you will be able to create your own albums on the site. Enter a name for each new album

3 Click here to add new photos to an album

4 Click here to browse your computer for the images you want to upload

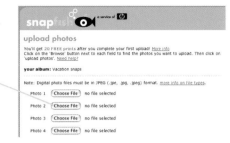

5 Once the images have been selected they will be displayed here. Click Next or OK to start uploading the images

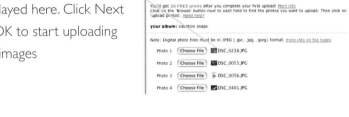

6 A window such as this may appear as the images are being uploaded. This may take a few minutes, depending on the size of the images

7 Once images have been uploaded they can be viewed in your albums and you can also give other people access to these

Online printing

As well as online image sharing, online printing is another growth area for digital photography. Companies that have previously produced prints from traditional film have now developed online sites that can be used to upload digital images and then have them printed and sent to you. Most sites that offer online sharing also have an online printing service. To obtain online prints:

1. Access one of the online companies detailed on page 176

2. Click the Buy Prints option from an existing album on your page

Make sure that images are in the JPEG format before they are selected for uploading onto an online printing site. Otherwise they may not be accepted.

3. Click here to continue with the print ordering process

...cont'd

4 Select how you would like to choose the photos for printing. This can usually be done from one of your online albums or someone else's album, or you can upload them from your computer

If required, edit images in an image editing program before they are sent for online printing. Very few images are perfect when they are captured and some careful editing can make all the difference to the final printed image. If possible, do the editing in TIFF format and then save the final image as a JPEG.

5 Enter the sizes and quantities for the selected image or images

Photo Selection:
Click on the image below to change your selected photo.

Resolution:
2240 x 1488

Product	Price	Quantity
4 x D Digital Reprint(s)	$0.19	2
4 x 6	$0.19	
5 x 7	$0.99	
3.5 x 5	$0.19	
8 x 10	$2.99	1
4 Wallets 2 x 3"	$1.79	3
8 x 12	$3.99	

6 Click here to purchase prints for the selected items

What is 4XD?
Photographic Poster Prints
Print Finish: ◌ Matte ⦿ Glossy
Default is Smart Crop™ with glossy finish. More options.

▶ Add to Cart

◐ Customer Service
◐ Shipping Options and Pricing

Publishing images on the Web

Web pages are becoming increasingly popular with a wide range of people, from individuals to big business. In almost all cases, people want to include images on their Web pages. Particular file formats are used for inclusion on Web pages:

Three books that provide a general look at the Internet and Web page creation are:

- *"The Internet in easy steps"*
- *"Web Page Design in easy steps"*
- *"Web Graphics in easy steps"*

- GIF (Graphical Interchange Format) files contain a maximum of 256 colors and are therefore best used for graphical images such as logos. However, they can also be used for photographic images

- JPEG (Joint Photographic Expert Group) is the main file format for photographic images on the Web. JPEGs can contain 16 million colors

- PNG (Portable Network Group) file format is a relatively new one. It uses 16 million colors and lossless compression, as opposed to JPEG which uses lossy compression

See pages 119–120 for more detail about file formats.

Using images carefully

When using images on Web pages there are some general points that should be kept in mind:

Applets (small self-contained programs) can be used to create special effects for Web images. One program to try is Anfy at www.anfyteam.com

- Use images for a specific purpose, not just because you can

- Keep the file size as small as possible

- Limit the number of images on a single page. If you use a lot of images then their impact will be diluted

- Use thumbnail images where possible. These are small versions of larger images. Users can then be given the option of viewing the larger versions by clicking on the thumbnails

- Add alternative (ALT) text for images so that blind or partially sighted users can have the textual alternative read out by their online readers

Optimizing images

If there is one thing that should be remembered above all else for images that are to be displayed on the Web, it is file size. The bigger the file, the longer it takes to download through an Internet connection and onto a browser; and the longer it takes, the more frustrated the user becomes. It has been calculated that Web users are prepared to wait for no longer than 17 seconds for a Web page to download. After that they become increasingly irritated or move on to another site altogether, possibly never to return.

When you are considering the issue of images and file size the following points should be near the top of your checklist:

- Do you really need to include the image? Does it add anything to the website or are you only including it because you like the image yourself?

If possible, try to keep images for the Web well under 100Kb in size.

- Can the image be made smaller? For instance, could it be cropped so that any extra parts are removed?

- Can the image be included as a thumbnail? This enables the user to see a small version of the image, which they can click on and enlarge if they are interested

Another consideration for file size and downloading time is that not all users will have a fast broadband Internet connection with which to access your pages. People accessing the Internet via dial-up connections through modems will be restricted to speeds of 56Kb per second at best. If you feel this is going to be an issue for your pages then be very frugal with your images. If you are not too concerned then design your pages with the fastest connections in mind and hope that those who need to will upgrade at some point.

A lot of digital cameras on the market today are capable of capturing images at sizes that are far too big for publication on a Web page. If you are going to be using a digital camera just for Web images then an entry-level one would be more than adequate for your needs.

Professional level image editing programs such as Adobe Photoshop have options specifically designed to optimize images for use on Web pages.

If you are using images on a personal Web page then downloading time may not be such an issue. But if you are creating a corporate website or an intranet then there should be a clear policy regulating the use of images.

Emailing images

Email is one of the most accessible and effective elements of the Internet. Communication is fast and cheap and it is an excellent way to send images around the globe in seconds.

Some of the uses for email images are:

If you have to email very large images to someone, contact them first so that they know what to expect and will not be surprised when their email program takes much longer to download messages from the server.

- Letting family and friends around the world know about a new arrival – and letting them see him or her

- Holiday snaps before you have even got home yourself

- Business use, such as emailing an image of a piece of broken equipment to see if an online solution can be found

- Business documents that have been scanned can be emailed as digital images. (Be careful with these types of images if there is a lot of text – the images will have to be big enough for the text to be visible, but not too large, or they will be too slow to download)

If you are unsure whether the recipient of your email will be able to open a particular file type, save it first in your image editing software as a GIF or a JPEG.

- Before you start emailing your images you should consider the format in which you are going to send them and the method the recipient is going to use to view them

As with Web images, it is best to keep images for emailing as small as possible as this speeds up the downloading time. However, if the recipient intends to print out the images then you may want to increase the resolution so that they get as good a hard copy as possible. Even if the recipient does not have an image editing program, they will still be able to view the image via their Web browser, as long as the file is in GIF or JPEG format. If they have an email connection then they will almost certainly also have a browser. To open an image all they have to do is double-click on the email attachment and the browser will automatically open it. It may be advisable to include instructions to this effect in case the recipient is unsure about what to do with the attachment.

Images can be attached to emails in the same way as attaching any other type of file.

Creative email options

For anyone who wants to get a bit more creative when emailing images, a lot of image editing programs have options to help. To do this, in Photoshop Elements:

1 Select an image and access the Share>E-mail... option from the Photo Browser

2 Enter a message for the email and select an option for the design of the image in the message. Click OK

3 When the email is sent, the image is included within it, according to the design option selected in Step 2

iCards

For Mac users there is an online option for including your images within online greetings cards, called iCards. These are available from the .Mac service at www.mac.com. The general iCards can be used by all users, Windows and Mac, but in order to incorporate your own images you have to subscribe to the .Mac service. To send iCards containing your own images:

1 Access the iCards page within the .Mac site and click here to create a card containing your own image

A lot of online sharing and printing sites have options for creating cards containing your own images.

2 Select one of your images from a directory within the .Mac service and click here

3 Enter the text for the message and select a style

4 The message is created as an iCard which can then be emailed to as many recipients as required

5 Click Send Card to send the iCard to the selected recipient(s)

Portable devices

As well as digital cameras, there are an increasing number of portable devices that can be used to store and display digital images. These include handheld computers and the version of Apple's iPod called the iPod Photo. These devices can have images downloaded onto them from a computer and, in some cases, they can receive images directly from a digital camera or a memory card. In the latter instance, an adaptor can be used for the memory card that is then attached to the portable device.

Portable devices can be used to view digital images, either individually or in a slideshow, or simply used as a backup in case the images are lost from a memory card. If you are travelling for any period of time and taking a lot of images the portable device can be used to store them and so free up your memory cards to take more shots. In general, portable devices perform a number of other functions as well as being able to store digital images.

Portable devices, such as the iPod Photo, are an excellent way to display, store and archive digital images

Index